UNLOCKING THE SECRETS IN OLD PHOTOGRAPHS

by Karen Frisch-Ripley

Ancestry®

Library of Congress Cataloging-in-Publication Data

Frisch-Ripley, Karen, 1955-
 p. cm.
 Unlocking the secrets in old photographs /
 by Karen Frisch-Ripley.
 Includes bibliographic references and index.
 ISBN 0-916489-50-7 (paperback)
 1. United States—Genealogy—Handbooks, manuals, etc.
 2. Photographs in genealogy. 3. Oral history. I. Title.
 CS49.F75 1990
 929'.1'072073—dc20 90-40642
 CIP

First printing 1991

10 9 8 7 6 5 4 3

To my father and to the memory of my mother,
who, along with her mother, taught me the value
of family photographs

THE AUTHOR

Born and raised in Rhode Island, Karen Frisch-Ripley has been an avid reader since childhood when she also developed an interest in writing and drawing. She has traced her lineage back thirty generations to the year 1100 through England, Scotland, Germany, and Wales. A former teacher, she received a Master of Arts in Victorian literature from the University of Rhode Island, with courses at the University of London, and holds undergraduate degrees in English and art from Rhode Island College. She is the host and writer of *Pet Talk,* an award-winning cable television show on pet care, and she is active with Volunteer Services for Animals, working to aid homeless animals. She lives in Rhode Island with her two dogs and two parakeets in the house that once belonged to her great-great-grandparents.

CONTENTS

ACKNOWLEDGMENTS

This book could not have been completed without the many individuals who offered their support during various phases of research and writing.

I wish to acknowledge the assistance of the Rhode Island Historical Society Library staff, who, over the span of years in which I conducted my research, were of great help in familiarizing me with the many outlets available to researchers. I also owe a debt of gratitude to several authors whose works helped me chart a course through the history of photography. Especially useful was *Collection, Use, and Care of Historical Photographs* by Robert A. Weinstein and Larry Booth, which offered a comprehensive study of the history of photographic methods from 1839 to the present. Time/Life's *Caring for Photographs* contains an informative section on professional techniques used in restoring old photographs and prints.

All photographs within this book are from the author's collection. The reproductions are the work of photographer Mark Anderman of the Terry Wild Studio in Williamsport, Pennsylvania. I wish to express my appreciation to him also for his reading of my manuscript and his input with some of the more technical aspects of photography; to photographer Carol Briden of Providence, Rhode Island, for her editorial guidance with the chapters on the history and restoration of

old photos; and to my friend and fellow writer, Jo Ann Ferguson, for her counsel throughout.

I wish particularly to thank my editor, Robert Welsh, and the editorial staff at Ancestry for recognizing the need for such a book.

I must mention my many relatives who have shared their photographs and memories with me over the years. Those who are no longer with us in this life will always live through the stories they related, for I could not help but remember them with affection as I wrote this.

Karen Frisch-Ripley
Pawtucket, Rhode Island

1. THE FIRST STEP: IDENTIFYING THE FAMILY

Though the streets still remain, many of the houses in which our nineteenth-century ancestors resided have fallen victim to the ravages of time. Where stately urban dwellings once stood, blank pavements and empty lots, broken only by tufts of grass, face an uncertain future in cities that were once full of hope and promise for earlier generations. In rejuvenated areas, new homes may stand on the spot where our ancestors began a new life in this country. Usually, outside of a few items—jewelry that has been passed down or furniture that has survived in cellars and attics—photographs alone have endured from that earlier generation.

Few objects possess the ability to transcend time as old photographs do. They are our single, most immediate link to the past, outliving memory and closing the distance of years as if no time had elapsed at all. In the split-second wink of a camera's eye, a photo refuses to let its subjects pass into memory but instead keeps them fresh and vibrant long after death.

Such fragments of yesterday's society have overlapped into the present, merging imperceptibly with our current world just as articles from long ago outlived their usefulness to become the antiques of today. When a photograph of your

great-grandfather so closely resembles your father in Victorian costume that it is difficult to tell one from the other or the eyes of an ancestor in a sepia-toned photograph are as familiar to you as those of your second cousin on your mother's side, you realize that elements of the present existed in the past as well.

My search to identify photographs of my ancestors began unintentionally with the discovery of a Victorian photograph album that came to light one Christmas Day about fifteen years ago. Neither my father nor my aunt knew its origins. It had always been in its dark corner of the living room in the house in which they had grown up, never questioned and rarely opened. Their indifferent verdict was that it must have belonged to their father's mother.

The album was put away until a rainy summer afternoon several years later when I took it out to examine it again. The album was unusual enough to capture anyone's fancy. Its ivory-colored cover pictured a stone church in a blue-green woodland setting and featured a gold clasp and corners above a base of worn green velvet. The album held a collection of thirteen perfectly preserved photographs along with a bouquet's worth of pressed flowers yellowed by time, and in the base was a music box that had in its day played "The Star-Spangled Banner." I had no success in identifying any of the photographs, and my curiosity grew as I faced an onslaught of questions without answers.

The assortment of old photos within contained the makings of a perfect mystery: one name, one date, one location, and one resemblance so striking we knew instantly from which side of the family the album had come. With those four unrelated clues as a guide, I set out to do what seemed an impossible task: to identify photographs that no one alive today could recognize.

As educational as it is fun, the challenge of identifying old family photographs is an intriguing puzzle that can be solved successfully by following certain steps. With the aid of records from a variety of sources and a few search strategies, a great deal of previously unknown or hidden information can be uncovered. Through careful research, we were able to put together a fairly detailed and generally accurate picture of people we never knew and of holiday celebrations in which we never participated—a past we knew only from history books.

With the simple addition of a name, the ancestors in the album took on a more romantic character. The sentimental value of the photos increased dramatically once we were able to ascribe an identity to them, because the faces were no longer those of strangers. Ancestors who were formerly nameless assumed their own personalities once they were identified and we were able to learn about their lives. More than mere resemblance, a family spirit lived on in the photos.

When the lure of one's ancestors beckons, the urge to respond is irresistible. The experience of identifying old family photographs is the best teacher, for it offers a unique learning experience that you would miss by hiring a professional genealogist. It is a mystery in which you are the detective. At the same time, it is a lesson in a history of the most personal kind.

In the process, you will learn to grasp the significance of single facts that mean nothing alone but together mean a great deal. You begin to recognize qualities rather than features in photos. I saw the qualities of endurance and strength in the face of my great-great-aunt Ernestine when I learned that she was not bound by Victorian convention but instead that she had stepped in to run the family grocery when her husband decided to try his hand at running a second business. You will feel you know and understand the daily

concerns of your ancestors when you not only have a photo but learn about the lives they led.

From the identification of the photographs, I was prompted to continue tracing the line, even though I went well past the point where photos would be available to me. I am not a professional genealogist, yet with the help of my local historical society and persistent research over several years, I was able to trace back, in a direct line, over thirty generations to A.D. 1100, before surnames were used. My search took me past a great-great-great-grandfather whose 104-year life spanned the nineteenth century; it took me from ancestors who fought in colonial America's Revolutionary War through Elizabethan England, where an ancestor was imprisoned and barely escaped being beheaded; and it led me to a line of twelfth-century Welsh princes and the loss of a castle the family had once owned. I knew nothing about these facets of my ancestry until I began my research.

The Value of Family Photographs

Our ancestors link us inseparably with a past we will never know firsthand, allowing us to take our rightful place amidst the family tree and establishing our place in the history of mankind. The faces in historical photographs that are so like our own provide a way for us to touch the more recent past. More than just a mirror into the past, photos allow us an intimate glimpse at our predecessors. Ancestors captured forever in aged prints receive a chance at a second life when we make the effort to identify them. Old snapshots reveal a different world to us as they visually recount old-time picnics, automobile trips, and holiday gatherings. After the turn of the century, when cameras became more commonplace, no family gathering was complete without photos.

While it is impressive to see photographs of nineteenth-century figures in their Victorian finery, nothing can compare

to the thrill of finding and identifying a photo of one's own ancestors. Such a discovery gives the past an immediacy and accessibility that nothing else can duplicate. You are at once able to claim the pageantry of history as your own.

For those individuals who died without leaving children, photographs have a poignant significance, for they are the only link with the present day. One of my great-great-aunts had no children of her own; her only connection to the present was through a formal photograph in a family album. Her name was not even engraved on her tombstone, a common occurrence even today, because no family member was left after her death to see that her name and appropriate information were recorded there. The headstone lists only the names of her parents with whom she was buried. Little else remains outside of memory and a single photograph to remind the present generation of her existence. Yet, judging from the accounts of those who knew her, she was a lively and popular woman who kept a parrot, taught her niece to play the piano, and ran a rooming house situated appropriately on Friendship Street.

Photograph albums in particular possess a unique timeless quality, leaving a legacy of love and devotion to the descendant fortunate enough to discover them. For many immigrants, photos were the only record of their earliest years in a new country, tangible representations of the beginnings of their new life. They sought permanence in photographs where memory secured their position in time for eternity and saved them from oblivion. They would have been pleased to know that their descendants are so interested in their legacy.

When you make the decision to identify family photos, you are invoking a lesson in history direct from your ancestors and embarking on what may turn out to be a lifelong journey into your past. If you scrutinize through careful eyes the many available clues that are left us, details of ancestors' lives will

be everywhere, falling into place around you to form a vision. You will be able to put together a fairly complete and generally accurate picture of ancestors you never knew.

Studying the Photographs

Few things are as annoying and as frustrating as finding unidentified photographs with seemingly intriguing origins. The provocative phrase "Bathing Beauties!" written on the back of a clear photograph of two smiling young women in early twentieth-century swimsuits with no clue at all as to their identity cannot help but arouse great curiosity. Obviously, the writer possessed a sense of humor and probably had a laugh at herself years later upon looking back at such old-fashioned styles by today's standards. It would certainly be interesting to know the identity of the person who expressed the sentiment, but it takes a great deal of careful examination along with determination to find the answers.

Ironically, the time such forgotten albums or boxes of photos tend to surface is almost immediately after the death of a close relative, usually the person who could have answered the questions you face upon discovering the photos. It is a prudent ancestor who has very thoughtfully penciled in the name and possibly even the date on the back of old photos for you. If you have such photos in your collection, you can thank your ancestors along with your lucky stars, for more than likely this will not be the case. Often family members were not identified in writing on the back sides of photographs because their faces were so well known to the family at the time that there was no need. The closer the relationship, the less likely the family would have been to write the name on the back. On some photos, in fact, all individuals present will be identified except family members, a complication that is particularly exasperating to the researcher.

Such familiarity is a bane to the modern-day genealogist or descendant who attempts to identify those same photos. Without the benefit of our ancestors' consideration to posterity or curiosity on our part, these photographs are destined to remain unidentified and basically useless; they might as well be sitting in a box in a closet somewhere. Hopefully, we will learn a lesson from this important step that our ancestors overlooked. We should get into the habit of recording such information because it becomes more difficult, if not downright impossible, to pinpoint the precise date of most photos a few years down the road. Our unidentified photos become, in turn, a tantalizing but frustrating mystery that our descendants in future generations will be forced to solve.

You should reasonably expect that photographs of large groups of individuals may contain a number of faces you will be unable to identify without fairly extensive research, if you are able to identify them at all. With larger families, there were greater opportunities to make use of the camera. You might be surprised at the extensive collection of old photos your family has accumulated and retained over the years. Some elements of picture-taking, in fact, never change at all; just as there are in bunches of modern snapshots, you will probably find a fair number of old photos in which the subject is off center or blurry or has had the top of his head chopped off.

Sometimes names will be written on the backs of photographs, both of which—the name as well as the subject—may be unfamiliar to you. Simple research, which may reveal significant clues, can often provide the answers. Some photographs, on the other hand, will be instantly recognizable to you, but the further back you go the faces probably will become less familiar. Photographs should be sorted out and organized so that the task of identifying them becomes

a more manageable undertaking. If they are already in an album, the job is done for you. If the photos are loose, they will need to be functionally arranged into some recognizable assemblage that is easy for you to work with. Keep photos of the same individuals together. If you find someone who can identify the subject, you will have identified many photographs at once.

We will begin by assuming you have no knowledge of what distinguishes a 1905 photograph from one taken in 1935. A later chapter deals with recognizing specific types of photographs. To start, in order to ascertain which photos were taken at roughly the same time, look for similarities in borders, edges, sizes, shapes, and styles of photos, as well as identical colors in photographic images, content, backgrounds, and subjects. You may find that certain photos form a sequence. You can tell at a glance which photos in your collection are the oldest, for the clothing and generally older appearance will give them away. As a general guide, expect to find tall plumed hats, bustles, and elegantly detailed dresses on women before 1900 and high Victorian shirt collars on men from the same period. White skirts and blouses were commonly worn in the first two decades of this century. Consult books on the history of clothing for more specifics and study more than one source to obtain a broad picture.

Identifying photographs in albums is sometimes easier because you are usually dealing with only one side of the family. Remember that your four grandparents probably all have sets of photos from their childhood. Loose photographs can be more difficult to identify but not impossible. If you are in possession of an album, an aged relative from the side of the family where the album originated should be able to recognize many of the family members from another time. When you speak to relatives about particular photos, they

may even remember the occasion on which certain pictures were taken. A new coat worn on an Easter Sunday many decades ago could spark a memory as fresh as the day the coat was first worn.

I have a series of old camping photographs taken on an island from the second decade of this century; upon seeing them again my great-aunt, one of the subjects of the photos, could remember amazingly specific details of the occasion and recognized everyone in the photos as old friends. Similarly, my grandmother was able to go through her old albums and identify nearly every individual in the photographs, from coworkers in the 1930s to cousins left behind in Scotland in the first decade of this century, even though she had not seen the people or the photos for decades.

Part of the value of old photographs is that they trigger memories in a way nothing else can. Even photos from our own lifetime stir up emotions long silent and cause us to reminisce involuntarily, whether we want to or not. Photos are a powerful stimulant to memory. Always give your relatives or those from whom you are seeking information time to study them without pressure or nagging expectation.

The photographs you are most likely to encounter in great quantity are photos from your parents' or grandparents' generation that would have been taken in the last hundred years or photographs from roughly the 1880s to the present day. Many of the photos taken in the last quarter of the nineteenth century and the early years of this century were a particular type of photograph. A knowledge of different styles will help you to ascertain the ages of old photos and is a valuable clue for the purpose of identification. Chapter 5, "Recognizing Types of Photographs," will aid you in determining the ages of historical photographs and specific styles.

Whether you are working with photographs on an ongoing basis or storing them during the interim, never leave them

near heat for prolonged periods of time and be careful of dampness, which can ruin photos that are delicate from age to begin with. Proper care and storage precautions for old photos will be discussed at length in chapter 6, "Care and Restoration of Photographs."

Some photos will be of more value to you in the identification process than others. Photos to be on the lookout for are clear, sharp pictures that contain groups of people, such as weddings, family outings, or holiday gatherings. Church and city hall records often list witnesses at weddings, and such photos will aid greatly in distinguishing between family members who may or may not look alike. Once they are correctly identified, you will have the original photo to use as a guide in identifying others. Photographs of grandparents with their grandchildren help to keep the many generations in perspective. Multi-generational photographs and portraits taken when all family members were of adult age are especially valuable, whether they were taken at home by a member of the family or in a studio by a professional photographer (see figure 1.1). Such photographs offer ideal opportunities for identification. More often you will find faded or blurred pictures. Nonetheless, their very fragility makes them valuable to you in trying to assign an identity to individuals or to date the photos themselves. You will find that the vast majority of photographs from the previous century will probably have a sharper, clearer image than you might imagine.

Some photographs may be unintentionally identified for you before you even find them. One great-aunt who retained a touch of animosity toward her sisters during and after their lifetime complained to me, in a moment of self-pity, that she had once been "cut out" of a photograph because she was not the favorite child among her aunts. Trying to imagine why anyone would deliberately take the trouble to separate one

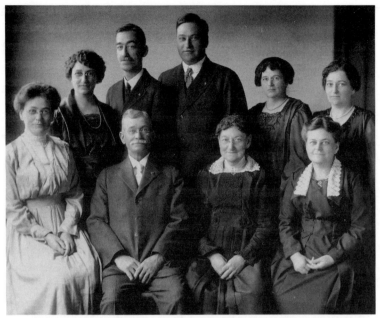

Figure 1.1. A studio portrait with all family members as adults. The author's great-great-grandparents, George and Isadora Cheek, are in the foreground surrounded by their seven children. Taken around 1910. Once identified, such a photo is helpful in identifying other snapshots of the same individuals.

individual from the rest in a group photo, especially when the picture was that of several nieces, I was surprised when I came upon a series of studio photographs relegated to a forgotten box in my grandfather's cellar.

There were six photos in all, obviously taken on the same occasion in about 1906, of two little girls with oversized bows fastened in their curls. In the photos, the children were arranged in various poses, from being seated primly to dancing like tiny ballerinas in their delicate ruffled dresses. The six photos had once been tied with ribbons in sets of three views each; the frayed ribbon still held three of the photos together. But the other series of pictures had indeed been separated, perhaps so they could be hung separately. From

previous research on other identified photos, I recognized the two children immediately as my great-aunt and her older sister, and I realized after studying them that these were the photographs from which my great-aunt had been "cut out." The photos had been described to me long before they ever reached me.

Talking with Relatives

The first step in identifying family photographs, particularly very old ones, is to identify the family, for you first need to know who the family members are that you need to identify. It follows then that while you are attempting to identify photographs, you will also be tracing your family tree. In the process, you will undoubtedly learn of relatives you never knew existed, unless you have already traced your family history and are familiar with the many branches a family can acquire. You may be forced to go back a number of generations, depending on the age of the photographs, as some photos may have been taken before your grandparents' time. Information on identifying specific types of photos that can help in dating them is discussed in chapter 4, "Public Sources of Information." If the photographs in question are standard cabinet photos on cardboard backings that are commonly found in Victorian photograph albums, for example, you probably will need to go back two or three generations to your grandparents' or great-grandparents' day. If the family photo you hope to identify is a daguerreotype, it could have been taken even a generation or two prior to that.

You should begin in the most logical place—within your own family, beginning with yourself and working backward. Write down what you know, or think you know, about your family starting with yourself in the present generation. Jot down basic information about your siblings; dates and places

of births, deaths, and marriages will suffice for the time being. Now do the same for your parents, listing their brothers and sisters, and also record those of your grandparents' generation—your four grandparents and their brothers and sisters. At this point you may need to consult other family members for exact names and dates, particularly if your family is a large one.

The best and most direct source is to talk with elderly relatives for information as well as old friends of the family who can serve the same purpose in lieu of deceased family members. You may be surprised by their answers to some of your questions. Most people can list their grandparents' siblings, but even one generation further back the process becomes more difficult, particularly if the next generation came from another country.

Although I knew my grandfather well, I did not know, for instance, that his father had two sisters and two brothers. Even after I learned of their existence, before I began my research I did not know which generation had come to America from Germany or that the children in my grandfather's generation were first-generation Americans.

Talk to older relatives such as those of your grandparents' generation who might remember their own grandparents (your great-great-grandparents) and who might be able to recognize photographs of those now deceased. Even if their grandparents died before they were born, which is very likely, and little was said about them within the remaining family unit, the information you need is still available to you through public records. Do not give up until you have located the answers you are seeking. Let enthusiasm be your guide; it will go a long way in discouraging moments.

One time I received a reply to a letter I had written to a relative on the opposite coast. In her letter my aunt, who had married into the family and was not as familiar with details

of the family background as her husband was, had stated, "All Uncle Harold remembers is that someone's name was Kohl." As it turned out, his own father had used the name Kohl when he first emigrated to America because that was his stepfather's name. Generally, you will find that more information will be available from female members of your family, presumably because they were often closer to their mothers than men were and because social boundaries between men and women were so much wider in the last century. It also seems to hold true that men remember less than women do about family details, perhaps because they were not as privy to gossip of a family nature as women were likely to be.

Learning about your family helps to keep each individual in perspective as well. My grandmother at age eighty and my great-aunt at seventy-four remembered my great-grand-mother from the other side of the family as an old lady—and these were the people I had hoped could identify old family portraits for me! To a great extent, we are victims of the limitations of our generation and life span. In order to identify family photos, we must overcome these limitations by making the most of the clues we do have.

Whether you are trying to identify one photograph or one hundred, the same principles apply. Listen for stories or family legends from your relatives, elderly or otherwise; their memories or offhand remarks such as, "He was so tall that the family had to saw off part of the doorframe for him to fit through," will give you a good indication of the height that will be noticeable in photographs.

Still, some photographs may be so old that even the elderly are unable to recognize them. When you speak to people, it is important to ask for particulars about the person they remember. Of two sisters, for example, who was taller? Who was short? heavy? dark-haired? and so on. These clues to identification can prove invaluable to you when you are

confronted with a photograph of two adult sisters and have no idea which sister is which (see figures 1.2 and 1.3). At the time your relatives living today knew them, they may both have been elderly and white-haired with glasses or heavier than in younger years and indistinguishable from one another in the eyes of a younger person.

But if your Uncle Fred recalls that as an adult Lavinia Williams was tall and slender and her sister Margaret was shorter and more stout, such information may be your only clue in differentiating between two grown sisters in a photograph that you strongly suspect is of the Williams sisters. If I had not talked to my great-uncle who was in his eighties at the time regarding two photos in particular, I would never have known the identity of either sister in one album.

Often a photo with two or more subjects is easier to identify than that of a single individual. Height and other specific comparisons are sometimes the only physical characteristics that do not change with the passage of time. Photographs, for all their value to us, can be deceptive; the shortest individuals can appear tall, for example, if photographed from a certain angle. For this reason, it is useful to have multiple photos of the same persons for the sake of comparison or, if photos are unavailable, descriptions provided by relatives who knew the individuals in question.

Asking for Specifics

So much depends, in the course of your research, on asking the right question of the right person at the right time as discrepancies in public records can keep identities elusive. It is crucial to the success of your endeavor to ask specific questions when you talk to relatives. The way in which you structure your questions is of vital importance. The more precise your question, the more specific the answer you will

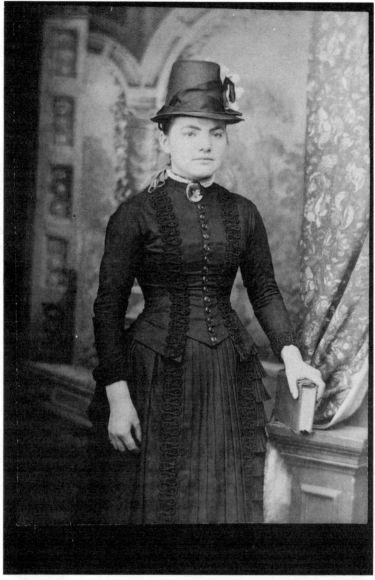

Figures 1.2. Augusta Kohl Fales (1870–1946). Typical example of cabinet photos taken around 1887.

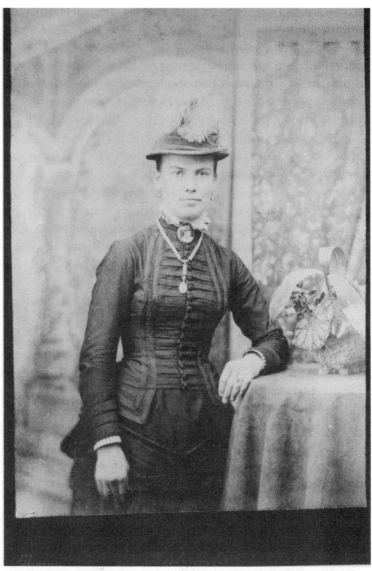

Figure 1.3. Ernestine Frisch Schwab (1862–1950). A great uncle remembered Ernestine as the taller of the two and Augusta as shorter and more stout. He provided the main clue that helped to distinguish one from the other.

receive. Avoid phrasing your inquiries in vague terms. Do not ask, "What do you remember about Aunt Kate?" This type of question puts people on the spot and does not encourage the kind of answers you are looking for. Ask instead, "How many brothers and sisters did your grandmother have? When did the Martin family come to America? Did their parents come with them? Did she ever talk about . . ." and so forth.

Such questions will bring concrete answers and jog the memory better than unfocused questions will. When I began my research, my casual approach to the subject made it hardly more than a diversion. I merely confirmed information that I already knew by asking questions that answered themselves such as, "Your grandmother was from Bavaria, wasn't she?" I hoped and intended that such a pointed inquiry would inspire more family tales and lead to an in-depth discussion of relatives who had passed on, but the tactic rarely succeeded; more often the conversation would drop shortly afterward.

Ask your grandparents specifically for photographs taken when they were younger if you have not already come across such photos. They will undoubtedly be pleased with your interest in the family history and willing to share with you whatever related mementos they have. It is important to let them know of your interest before they decide to get rid of any old photographs for lack of a better purpose for them. All families have different attitudes toward such keepsakes and regard them with varying degrees of importance; while my father's side of the family tended to save excessively, my mother's kept very little. My grandmother, herself, kept only the modern photographs we gave her while we were growing up. Concerned mainly with the present day, she discarded almost everything connected with the past except the photographs she gave me as a child and what I managed to salvage.

You might also inquire of relatives who have kept photograph albums if you can borrow them to make copies of the appropriate old photos within. Most old snapshots are held in place by corners pasted into the books to fit the size of the photos and can be easily removed. In this way you may be able to match up your photos with those already recognizable for positive identification. Consider carefully the arrangement of photos in albums. Photographs were generally placed in albums in chronological order as they were taken, just as they are today. The Victorian albums that contained music boxes usually held four cabinet photos to a page. The chances are strong that the contents of such albums are not haphazardly arranged.

The process of elimination is a significant factor in identifying photographs. If your grandfather had two brothers and two sisters and you have located an album that contains formal portraits of three brothers and two sisters, you may already know which family it is; your job will then be to distinguish between individuals. Similarly, if you know that an uncle died in 1930, and you have a photo from a wedding that took place in 1931, then you know that he cannot possibly have been present. Once again, the facts you collect from conversations with relatives will serve as key factors in directing you toward accurate conclusions. Basic knowledge of your family's history and thorough familiarization with dates of significance in your background will save time and guesswork.

Accurate record keeping is therefore essential in order to avoid natural mistakes or repetition of effort on the researcher's part. Chapter 2, "Keeping Accurate Records," is devoted to systems of record keeping and offers suggestions for organizing the information you compile. Much of your research will consist of combining facts, for facts discovered separately can become conclusive proof when compounded

with additional bits of information. My family had always lived in Rhode Island, yet among a group of relatives' photographs, I came across a picture of an unidentified man taken in Freeport, Illinois. Receiving a letter several weeks later from an aunt in another state in response to one I had written, I had nearly undeniable proof of his identity when she casually revealed that her mother's father had moved to Freeport soon after their arrival in the United States, leaving behind a daughter anxious for his safety who would have been greatly relieved to receive a photograph with reassuring news of his whereabouts.

Contradictions and Complications

Discrepancies are rampant in family genealogies for many reasons, only two of which are lapses in memory and confusion over individuals of different generations. In a close relative's photograph album, I found the words "My Birthday Party, 1939" printed neatly in white ink on the black page of the book. On the border of the photo above was written "February 7, 1939" when I knew for a fact that the owner's birthday was in October! Another contrary sign was the fact that one of the photos was of two children ice skating while another contained a group of young girls in summery cotton dresses, both on the same page.

Presumably the child of ten who appeared in the pictures and who owned the album labeled the photographs at a later date, judging by the neat penmanship, but the illustration offers a clear explanation of why it is best to take all potential leads with a grain of salt until they are proven accurate. Check with as many relatives as possible in your quest and do not be the least bit surprised if you receive contradictory information from different people. In tracing your family's history, you are always at the mercy of memory, either your own or that of someone else. You must try to assemble a general

picture based on the recollections of a number of people which will hopefully then form for you a version that is close to the truth. Sorting out errors in memory along the way is part of the process. Discrepancies in names and dates can be confirmed easily enough through a check in the vital statistics records in the clerk's office of the city or town where the event occurred, whether it be a birth, death, or marriage you are tracing (more on vital statistics in chapter 4).

An additional complication is that of family jealousies and differences that can cause people to tell half-truths or cloud the real story unintentionally. You may find you need to filter out slight distortions from genuine truth. My great-aunt felt that as the second child in a family of four she had always been unjustly overlooked. One sister was the oldest, the other the baby of the family, and the third child the only boy; she alone had no particular designation within the family structure. Stories she related about her sisters, both deceased, were always tinged with a slight case of antagonistic sibling rivalry and thus could not be entirely trusted for accuracy. Her exaggeration of the truth, however minor, biased her objectivity, thereby destroying the credibility her stories might otherwise have had.

A word of caution: do not believe all you hear when talking to different people. As hard as it may be to accept, some individuals have their own valid reasons for concealing information from you along with the rest of the world. Even if their private knowledge of an event that occurred many years ago may not directly seem to affect anyone living today (although it very well might), some relatives may be convinced that they are performing a service to the family by protecting such information and a disservice by revealing it.

For this project, you are forced to be a sort of detective, and without intending to do so you will necessarily turn up startling information. Be prepared to find some skeletons

along the way. As unlikely as it may seem, you cannot know for sure that your elderly spinster aunt had no children until you check the record books. Illegitimate births occurred in the past just as they do now, although not with the same frequency. In former generations, particularly in the late nineteenth and early twentieth century, a birth out of wedlock would most likely have been covered up or the child disguised as a niece or nephew.

It may seem strange to us today that even in the Victorian day, an age not so far removed from our own but one in which families were certainly closely knit, a surprising number of people either never knew about unwed pregnancies in their immediate families or pretended they did not. It was possible for a doctor, nurse, or midwife to be called in during the night to assist in the birth with no word of the event slipping out to relatives. Sometimes female immigrants arriving from other countries assumed new identities in America as "aunts" to their own children or invented deceased husbands to protect their reputations. Women jilted or abandoned by their husbands were known to declare them dead rather than face the Victorian shame and humiliation of openly admitting the truth.

Use your discretion when dealing with delicate family matters. An incident that would not be considered scandalous today could still be a sensitive issue to those of another generation who lived through an awkward time because of the event. If your mission is simply to identify photographs, such information may be irrelevant to your cause and is sometimes best overlooked. Your relatives may not even deliberately intend to conceal information from you; they may simply forget. This is one reason you need documentation to corroborate the word of anyone with whom you speak. Always verify your information through public records to

make sure your "facts" are indeed genuine and that information given you is precise and accurate.

If, for instance, a widow's second marriage did not work out, the chances are good that people connected with the woman will forget the event ever existed. I searched for months among city hall records, where I knew my great-grandmother's death certificate had to be, before my mother suddenly remembered that her grandmother had been married briefly a second time when she first came to America as a widow from England. I was searching for the name Barnes in the records when the death certificate was recorded under Kirkby.

The marriage had not worked out—her second husband was, as my grandmother termed it, a "rotter"—and they had soon parted, the husband dismissed from the memory of those who knew the wife almost as soon as he was out of the picture. He was, apparently, far from absent in the mind of my great-grandmother; in later years she refused to have a tombstone erected over her grave because she did not want the Kirkby name to appear on it. Her enterprising youngest son, however, found a clever way around the dilemma. Nearly thirty-five years after her death, he had the spot marked by a small stone that read, "Mother," and beneath it, "Mother of A. Barnes."

You may be surprised at the information your relatives never knew or do not remember. Even when you live in the same locale, it is still easy to fall out of touch with your grandfather's cousin's family because of the sheer number of descendants, especially when every child is a potential parent and families of ten or twelve children are common even in recent generations. In trying to identify old photographs, take advantage of all leads that you can think of. If you know that your grandfather worked in a certain mill, try contacting

someone who might have known him in those days, perhaps an old family friend or coworker from that time.

There are three ways in which to approach relatives on the subject of family photographs. Those methods are by a direct interview, through a telephone conversation, or in written correspondence. An oral interview in person is generally the most effective; the easy flow of conversation stimulates spontaneous answers and lets you adapt your train of thought and line of questioning to suit the opportunities for inquiry that arise. A handwritten letter from a relative may simply prompt another letter on your part, with more time lost in between. Another advantage of the in-person interview is that you can provide clarification if needed and reassure your subjects of the relevance of their memories. Most people who suddenly find themselves the subject of an interview often feel uncertain about the importance of their own observations when in reality they may have the missing link in your chain of information.

Try not to supply answers or influence people with your expectations; they may start guessing simply to please you, attempting to avoid the embarrassment of memory lapses on their part by giving you answers they think you want to hear whether the information is true or not. Use your own judgment in evaluating the answers you receive; promptly question those with whom you speak about discrepancies in their stories but appraise their statements and draw your own conclusions in private with consideration for their feelings. Do not assume that a momentary state of confusion or senility necessarily negates other answers elderly relatives might give you.

Remember that memories are frustratingly and unpredictably spontaneous. Do not underestimate the power of photographs which can trigger mental associations along with accurate memories beyond your expectations. Get relatives

into the habit of thinking of their past while keeping your project in mind at the same time. Far from being a dramatic exaggeration, the stark truth is that they may be the only individuals in the world to have the answers you need. Never take your sources for granted and assume they will always be there at a moment that is convenient for you, especially those already in frail health. Later, you may regret your own laziness in not contacting them when you had the chance.

When you interview relatives in person, be sure to take notes so there will be no confusion afterward on your part. It is easy and natural to respond enthusiastically to replies to questions that you raise, only to find that you have forgotten some of the details a day or two after the discussion has taken place.

If you are uncomfortable with the idea of telephoning or speaking with someone face to face, you may prefer to write, especially if the individual is a relative with whom you are not familiar or do not feel particularly at ease. If you receive no response after a month, however, do not be too surprised or disappointed. Call to follow up on your letter of inquiry. Most people understand how easy it is to procrastinate when it comes to writing letters, even more so if you are not closely related or if the person suspects that his reminiscences would not be of much value to you, a myth against which you will have to be on guard. The lack of an immediate response more often indicates a shortage of spare time rather than annoyance at your request.

Tempting as it might be, try not to overwhelm your subjects with too many diverse or dissimilar issues at once. Whether you are interviewing a relative in person or by letter, keep your inquiries direct, objective, and clear. Spread the material out among relatives as much as possible and get several versions of the same story for the sake of comparison. If you need a great deal of information, you might consider

using a clear questionnaire format. Make your form typewritten and double-spaced, leaving enough spaces for answers, and always include a self-addressed stamped envelope for the convenience of those to whom you are writing, particularly if you do not know them well. Such courtesy on your part might also stimulate a prompt reply and make them take your request more seriously. The disadvantage of writing, especially where the elderly or arthritic are concerned, is that the physical handicaps that come with age make it difficult not only to see but sometimes to write as well.

Though the telephone may be effective for obtaining quick answers, you cannot show someone a photograph over the phone, although today's fax machines have solved even that dilemma for you. Fax machines are now often conveniently located and available for general public use. Take into consideration your audience, as well as the various pros and cons of each course of action, when making the decision about methods of interviewing.

Relatives Out of State

Do not overlook the assistance that relatives out of state may be able to provide. Much can be accomplished by mail if no other form of contact is available, and you will have the security of a written source of information as opposed to word of mouth. You might inform the recipient of your letter of your interest in collecting old family photographs; often elderly relatives or those in the process of moving are willing to discard unnecessary articles. Far better that their old photos go to an interested relative than in the trash bin. Writing gives you the chance to list (in black and white) the information you are looking for and can help you clarify the specifics you need to know in a concise form of inquiry.

Senior aunts or uncles who live out of state welcome news from home and enjoy the opportunity to share their

knowledge of the family with kin who are truly interested. They have many significant stories to tell about their own upbringing and will probably be able to enlighten you regarding aspects of the family about which you have questions. Particularly in families with many children, distant relatives, even second cousins, can easily fall out of touch through ensuing generations. Elderly relatives are still the best source to help you identify photographs, especially if the photos are of family members from earlier generations.

However, it is not advisable to send original photographs through the mail. The chances are too great that they will be lost or damaged in transit, or perhaps not even returned to you at all, for a number of possible reasons. Instead, send a photocopy. Although it is unwise to make great quantities of copies from original old photographs as exposure to ultraviolet light can be damaging, a few copies will not harm them and will give you peace of mind in knowing that your originals are safe. Also, there are special heat shields available to protect the picture during the process. Photocopies done on a good machine are nearly as clear as the photos themselves, and today's laser copiers produce sharp, vivid duplicates in color or black and white. Copies save wear and tear on the originals, and you can write on them where you might not want to mark the actual photos. Whenever possible, do the photocopying yourself so that you are always the one handling the photos. Never part with an original if you can help it.

If you find yourself with duplicate copies of old photographs and would like to send one to a relative who would enjoy having it, maybe even as a gesture of appreciation for information they have given you, be sure you mail the photo in a crushproof, thickly padded envelope with plenty of cushioning. Notify the people in advance that the photograph will be arriving by mail and when you plan to

send it so that they may be on the lookout for it by estimating the approximate date of arrival. For safety's sake, you might choose to insure the package, though this measure is of little consolation if the photograph is lost and never located. However, packed securely, there is no reason why the package should not reach its destination safely. I received several delicate ancestral photographs from England carefully wrapped inside a tea cozy when a cousin was cleaning out.

Making Note of Details

You can train yourself to notice different elements of photographs by cultivating an eye for detail. When examining photographs, note room arrangements, clothing styles, and details of the surroundings, but more importantly, look at faces and features and study them relentlessly until you know them intimately. The essential characteristics of many faces do not change significantly from childhood through old age; although noses may spread a bit or weight may be gained, eyes always remain the same. In order to be able to distinguish one relative from another in photos, you must be thoroughly acquainted with individual differences, so begin now to familiarize yourself with the faces you are trying to identify. Family resemblances are often very strong from one generation to the next or even over several generations, and gradually you will find yourself recognizing features as those of a certain family (see figure 1.4).

The most immediate and basic skill you will use in attempting to identify photographs, hardly foolproof though a necessary one, is to look for family resemblances from one photo to the next. When not talking to relatives, try using your own skills of recognition. This is not to be used as conclusive proof; family likenesses among kin are but one step in a sequence of discoveries and judgments that you will have to make. If you plan to identify old photographs, it is essential to spend

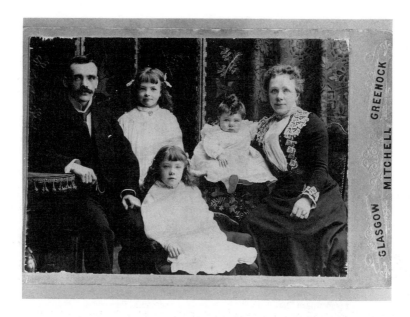

Figure 1.4. A family portrait taken in 1903 by the Sandyford Sudio in Glasgow, Scotland, of William and Frances Black with children Janet, Elizabeth, and Robert. In later photographs the two daughters are always distinguishable from each other by their eyes. Janet's were piercing, like their father's, while Elizabeth's were more pale, like their mother's.

time studying each photograph with a critical eye. Watch for particularly noticeable features, such as bushy arched eyebrows, an outstanding luminescence to the eyes, or a straight, thin mouth and square jaw. If the same attractive, wavy-haired, bright-eyed young woman appears in many photographs taken on various occasions, she is probably a family member. Frequent repetition of faces indicates the subject might be a relative or close friend, an especially important clue with loose photos that could have come from any branch of the family.

Watch not only for resemblances, but observe which individuals appear together in photographs and try to determine a relationship based on information you have collected from your family. Some photos can look like living relatives

Figure 1.5. Figures 1.5 to 1.9 show the transformation a face undergoes in a lifetime. The author's grandmother, Dora Perrin Frisch, shown over five decades. Dora on the right with her sister, taken before 1910.

in costume. Rather than assume identities, you need to probe further for conclusive evidence. Once you have a handful of photographs of individuals from other generations positively identified by someone who has looked at them closely and who knew the subjects, your task will be easier when you come across more photos of those same individuals. If you have a discriminating eye, you will be able to recognize the same faces the next time you see them (see figures 1.5–1.9).

Careful analysis of details in photographs will help you identify individuals you are unable to recognize initially. Eventually, facts from your family history will bear each other out. It is important to make your interest in old photographs known to as many family members as possible along with their friends and acquaintances. If you spread the word that you are interested in collecting photos, snapshots will be directed

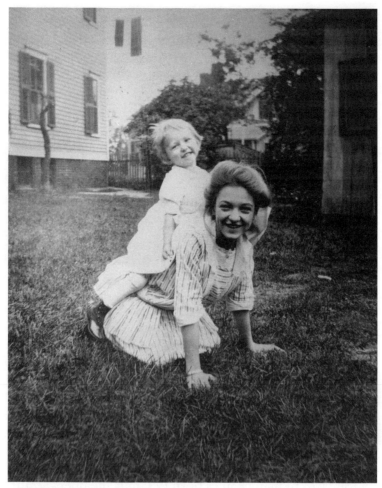

Figure 1.6. Dora Perrin Frisch. Taken around 1912.

your way accordingly. As people age and move to smaller quarters that cannot accommodate a lifetime of accumulated belongings, they begin to discard nonessentials. Not surprisingly, too little storage space in the homes of relatives may prove your ally as you build your collection of family photos.

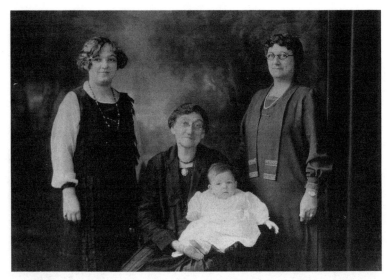

Figure 1.7. A resemblance passed through four generations. Dora Perrin Frisch with her grandmother, daughter, and mother. Taken in 1926.

Sometimes, regrettably, conclusive proof of age or identity is impossible to obtain. Remember that in some cases you will never be 100 percent certain because there may be no one alive today who can assign an absolutely definitive identity to some photographs. When such unfortunate occasions arise, we must be content with our own investigative work and intuition. Formal studio portraits of infants are by far the most discouraging and the most difficult to identify (see figure 3.1); even distinguishing features such as light eyes or arched eyebrows that run in a family will probably be found in the faces of many babies born to family members around the same time. Casual snapshots tend to be less challenging in that regard because of other elements in the photos such as a house in the background or familiar objects that can serve as clues. As children grow, each face assumes its own distinct features that are easier to recognize when we see them again. The presence of an adult in a baby photo offers at least a ray of hope for eventual identification.

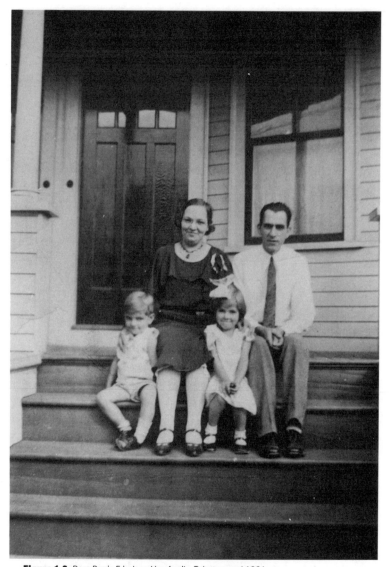

Figure 1.8. Dora Perrin Frisch and her family. Taken around 1931.

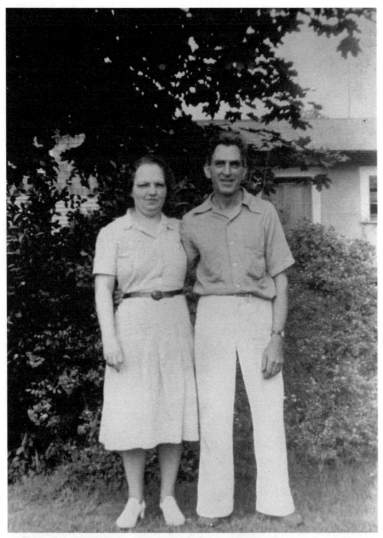

Figure 1.9. Dora Perrin Frisch with her husband. Taken around 1943.

If no one alive today can confirm the identity of your photographs, then you must rely on other clues. The next step is to ascertain the approximate dates of the photos, for

once the photographs are dated the correct generation can be established. At this point, a thorough knowledge of your family tree will be of immeasurable help to you. Chapter 3 will explain how to date photographs and how then to apply that knowledge to your goal of identifying them.

Yet even with unrecognizable photographs, we always have the consolation of knowing that our search goes on, and that we may yet uncover some new information that will help us in our struggle to identify the seemingly unidentifiable. Where our ancestors' foresight in labeling those photographs or, perhaps, their oversight in not labeling them left off, our own initiative picks up.

As you sort through old photographs, examine each one carefully and compare features, speculate, study, and give free rein to your imagination. Delve into your background with patience and persistence and never lose sight of the conviction that you will find the answers you need in one of many possible places. Invest in a magnifying glass to detect details that can help you in your search. Verify the information you have received verbally in public records and do not be surprised when those records do not correspond with what relatives have told you. You will find that some of the answers you thought you had all along were really incorrect assumptions and that clearly there is much of the family history that you have yet to learn; you may even find that your search is not to end in this country but will instead continue in public records in foreign lands. With a little imagination backed up by research, you will find that your discoveries will be well worth the effort it takes to uncover them.

2. KEEPING ACCURATE RECORDS

In trying to identify family photographs, you will need to become thoroughly acquainted with your ancestors individually. Therefore, it is essential to know the particulars of their lives, such as dates of birth and death and parents' names. This is especially true if your family is a large one with cousins descending from many branches, a situation in which names are likely to be repeated through successive generations.

Think of your family tree like you would a maple tree; while the trunk rises smoothly without interruption until the first few thick branches begin to spread, as you go further those main branches extend out into countless limbs and eventually into thousands of tiny twigs. So it is with your lineage; counting only the parents of each of your ancestors, every generation doubles in number. Even going back four generations, to the time of your great-great-grandparents, you will count thirty individual ancestors, sixteen in your great-great-grandparents' generation alone. One generation beyond that would reveal thirty-two more ancestors, all great-great-great-grandparents.

Even if your great-grandfather came to America with only four brothers and sisters, three generations later those four

siblings have probably married and multiplied many times over. Unless the family is a very close one, you would need a scorecard to keep track of everyone, particularly in light of the tendency of the American family to expand into every corner of the continent.

While it is best to begin the process of identifying photographs of ancestors by asking family members directly if they recognize the subjects, you will also need to collect information along the way; the victory of having photos identified is a hollow one without knowing something of the personalities behind the faces. Particularly with very old photographs, it is natural to want to know more about the lives, interests, and concerns of our predecessors. A great deal of miscellaneous information can be accumulated through serious or even casual inquiries, making it necessary for you to keep close track of details you uncover about the happenings that shaped the lives of your ancestors. The interesting tidbits of their lives—personality traits, outstanding achievements, their own peculiar interests—are the key that provides the magic that will transform them into distinct characters and breathe life into the faces in the photographs.

Much more information will be available to you if someone in your family is still living who actually knew the individuals in the photographs. Your discoveries will depend greatly upon your communication with these relatives. They may recall unusual anecdotes about the person in question regarding their pets, careers, hobbies, habits, and lifestyles. Bear in mind that you will acquire knowledge of stories that might otherwise be lost forever to future generations, so do not delay in your search as time is of the essence. You will want to compile as much information as possible, as even seemingly insignificant facts may have relevance later when new details come to light.

Since the success of your search is dependent on your knowledge of your own family, getting into the habit of keeping organized, precise records from the time you begin your research will help you stay on top of who is who with less confusion. While you are assembling the information you collect, the use of a written chart will help you to maintain accurate genealogical data. A clear idea from the beginning of the information that you will need from relatives will save you a repeat visit; it is wise to get as much information as you can at once. All pertinent information should then be stored in a clear, simple, organized fashion to avoid duplicating your efforts.

The complications you will encounter along the way make it not only desirable but necessary to keep accurate records. Information may be difficult to locate initially, and statistics can be unreliable when you finally do locate the records you seek. Names were sometimes changed on census records and other forms to protect the innocent as well as the guilty; our ancestors were often guilty of falsifying names, ages, relationships, places of origin, or any other information that they needed to in order to achieve their goals. Proof of identity was not required as rigidly at the turn of the century as it is today. One of the most common sources of confusion in searching through public records is the changed spelling of surnames, particularly those with an obviously foreign ring to them. When my French-Canadian forebears arrived from Quebec, they spelled their name Perron, with the accent on the second syllable; a generation later it had become Perrin, with the accent on the first. Such spelling alterations can make research outside of America trickier than it needs to be if you are not aware that your family's name was changed at some point. The problem of incorrectly spelled surnames occurred as well because names were frequently phonetically transcribed by immigration officials who were unable to

communicate with non-English speaking newcomers. Upon her arrival in America from Germany, my great-grandmother served as a domestic in a household of children who could not pronounce her Christian name of Koleda; based on that source of difficulty, she adopted the name Anna, a moniker that followed her to the grave and appears on her headstone. For these and other reasons, a well-organized family chart is the only effective solution to avoiding confusion in your own record-keeping endeavors.

Genealogists use several types of charts in recording their data. Individual worksheets, four-generation pedigree charts, and family worksheets that are organized by heads of households all contain their own particular collection of information. A standard worksheet can be found in any genealogical how-to book. Two are reproduced here to give you an awareness of aspects to consider regarding your ancestors and their lives (see figures 2.1 and 2.2).

A standard worksheet might include information such as name, dates of birth, death, and marriage, children's names, and other family details. For the purpose of identifying photographs, other material is also useful to have. A standard worksheet, modified to fit your needs as an identifier of photographs, will be a quick and easy reference point for you and can be used to record in detail more extensive information. You should use the same chart for all your ancestors and make copies of the original form so that you will be able to find and record information quickly and efficiently. By using a standardized sheet for each ancestor, you will be less likely to make the common but potentially confusing mistake of placing information on the wrong lines. A sample worksheet listing all the information you should be seeking is included in this chapter (see figure 2.1).

The family chart categorized by listing the head of each household is particularly useful, as is the chart that contains

```
┌─────────────────────────────────────────────────────────────┐
│                    INDIVIDUAL WORKSHEET                       │
│  Name _____    Code Number _____      │
│  Nickname _____   Parents _____       │
│  Date of Birth _____   Place of Birth_____    │
│  Date of Death _____   Place of Death/Cemetery _____   │
│  Brothers/Sisters _____   │
│  Spouse _____   Spouse's Parents _____     │
│  Date of Marriage _____  Place of Marriage _____     │
│  Children/Dates of Birth _____   │
│  Occupation(s) _____   │
│  Residence(s)_____    │
│  Education/Schools/Dates _____   │
│  Religion/Churches Attended _____   │
│  Physical Characteristics _____   │
│  Anecdotes _____    │
│  Miscellaneous _____    │
│                                                               │
└─────────────────────────────────────────────────────────────┘
```

Figure 2.1. The individual worksheet. You should keep a worksheet such as this for each ancestor. With the number of ancestors doubling with each generation, such a chart is essential for recording the amount of information that accumulates on individual relatives.

four generations of family members on one sheet (see figure 2.2). Both worksheets help to keep individual generations in perspective so that you know at a glance which ancestors and relatives belong to a particular family or generation. To simplify matters, you may wish to make use of the family worksheet for quick reference regarding individual families within your larger ancestral family. This worksheet might contain information such as the name of the head of the household; his wife's full name; code numbers for each so you can readily know where they fall within the structure of the family tree; brief descriptions of their lives prior to marriage, including other spouses; residences and

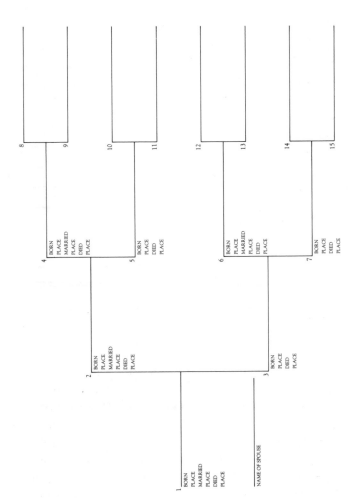

Figure 2.2. A pedigree chart like the one above shows at a glance the direct line of descent over four generations and depicts the relation of family members to one another.

occupations; all information pertaining to their children; dates and places of birth, death, and marriage for everyone in the family unit; miscellaneous data; and research references used in case you need to refer to them again.

Most genealogical texts suggest that you assign a number to each ancestor beginning with yourself as *number 1,* your father as *number 2,* your mother as *number 3,* your father's father and your father's mother (your paternal grandfather and paternal grandmother) as *numbers 4* and *5* respectively, your mother's father and your mother's mother (your maternal grandparents) as *numbers 6* and *7,* and so on. All male ancestors will thereby assume even numbers while females will receive odd numbers. It is not likely you will need a numerical system in dealing with photographs, but you will want to assign each ancestor a code number to avoid confusion if your family has several members in different generations by the same name. The presence of three John Robertsons, for example, can be nothing short of bewildering in conversations of a genealogical nature.

There are computer programs available that can store and retrieve information on a particular ancestor at a moment's notice and conserve space simultaneously. Such a program can save you the bother of searching through reams of paper for the same material. It is a good idea to invest in a loose-leaf notebook for the many pages you will collect as ancestral notes accumulate rapidly, more rapidly than you might sometimes wish. A genealogy is a documented account of family relationships comprised of both oral and written records; hence, stories of your ancestors communicated to you by elderly relatives who are still able to remember them are of great value indeed. As you collect more information and absorb the volume of knowledge about your own family, your written records will grow in quantity accordingly. Accurate records will save you much time and trouble.

One source of confusion you should watch for is that of adoptions within the family. Fortunately, today such an event is usually common knowledge within families. Be careful not to look for family resemblances in photos where none exist. Be sure you understand precise relationships between individuals within your family. Technically, there is no such relationship as that of great-aunt; the term exists to ease the awkwardness of referring to an aunt as a grand-aunt. My intent is not to perpetuate an inaccuracy but to lessen confusion; therefore, the term will continue to appear from time to time in the chapters that follow.

To clarify your understanding of family relationships, consider the following: according to Webster's dictionary, individuals must be in the same generation to be first, second, or third cousins. The number of generations removed you are from another relative refers to the relationship between yourself and a cousin of a different generation, either earlier or later; you and the child of your first cousin, for instance, are first cousins once removed. You and the grandchild of your first cousin are first cousins twice removed (or removed by two generations). Those to whom you refer as your great-aunts are actually the sisters of your grandparents; female relatives of that generation are actually your grand-aunts, though the term great-aunt is more popular. Half brothers, on the other hand, have one parent in common; stepbrothers are the children of former marriages whose parents remarry, and they share neither a birth mother nor a birth father. The term in-law also refers to the spouse of your actual in-law; your husband's brother's wife is your sister-in-law, just as she is your husband's. Lastly, a father and son with the same name are considered senior and junior. A different middle name does not constitute the use of the designation junior. A grandson named after his grandfather may be called James Thomas Smith, III.[1]

Considering such potential sources of confusion, the need for an organized worksheet becomes very obvious indeed! Your own worksheet should contain specifics such as name and number, and nicknames should always be recorded on your worksheet. At the start of my own research, I found myself bogged down in confusion over the common family belief that my great-grandmother had been married twice, once to a man by the name of Ludwig Frisch and the other time to Louis Kohl. Vital statistics records revealed that she had married her first husband, Ludwig, at the age of twenty-four and had been widowed at sixty-five, and I found no evidence of a second husband in the marriage records of the city in which she had spent her life in America. No reason existed for her to move to another community after age sixty-five; four of her five children lived nearby, and her death record was among those listed for the city.

By tracing back a generation further, I discovered the source of the confusion. My great-great-grandfather Frisch had died in Germany and his widow had remarried a man by the name of Kohl. Her son, Ludwig Frisch, was known to his many American friends and to the friends of his stepfather, alternately, as Ludwig Frisch and Louis Kohl, using his stepfather's name informally and the American translation of his Christian name when the family came to a new country. It was perfectly natural that his stepfather's friends would think of him as a Kohl, yet even a generation later, in-laws within the family had forgotten the name of the second husband. With distant relatives, the tendency toward inaccuracy is magnified many times over.

Therefore, you will want to indicate nicknames used within the family and make a note of possible sources of confusion. Particularly in talking with relatives, you must make it clear to which John Robertson you are referring, the one two generations back or three. The designation of junior is a

pleasing addition to a name for the sake of posterity, but it can be a major problem to the family genealogist who is investigating the family's background several generations later. The aunt our family always knew as Mae had actually been christened Bertha Mae after her mother, who was always called Bertha; for the sake of convenience it made sense that her daughter should be nicknamed Mae, but the nickname was potentially troublesome to anyone trying in vain to locate her under the name of Mae in public records.

Following the name, nickname, and assigned number, in sequential order, your worksheet should contain space for the ancestor's date of birth and birthplace; date and place of death and the name of the cemetery; parents, brothers, and sisters; husband or wife and the date and place of marriage; children and their dates of birth; similar information on remarriages; occupations; residences during the family's lifetime; miscellaneous information such as family customs during holidays; details of immigration for those from another country and the specific area of the country from which they emigrated, if it is known; descriptions that include significant physical characteristics to help you distinguish the individual in a photograph; and any anecdotes that reveal interests and personalities.

In order to identify family photographs, it will be necessary for you to know the ages and birth dates of the ancestors you will be tracing. If you find that no one alive today can identify the photographs, and you must ascertain the age of the photograph and its subject for a positive identity, you will need to know which ancestors fall within the dates of the period in which the photographs were taken. Discovering the approximate age of a photograph can help you determine the generation of the subject in a photo.

It is truly amazing how closely a modern-day relative can resemble an ancestor from another day, and such likenesses

are all the more surprising when the relationship is not within the immediate family. As mentioned previously, sometimes an ancestor three generations away will look so much like your own father that it will seem as if the photo is indeed a portrait of your parent in costume. In some cases, only the clothing and surroundings will allow the viewer to differentiate between individuals to determine the actual generation. Photographs have an uncanny ability to capture the various expressions of their subjects, some of which reveal hitherto unnoticed resemblances to other branches of the family. It is one of the many values photographs possess that make them so important to us. The next chapter will deal with specific techniques for dating photos, but first you must know the ages of your ancestors. A knowledge of important events in their lives will help you keep each generation in perspective along with the birth order of the children of that generation (see figure 2.3).

It is useful to know parents' names, particularly those of immigrants. Families and individuals emigrating to America generally brought so few personal possessions with them when they sailed that photographs from other countries hold special significance. Our relatives from earlier times were bound by tradition as much as we are bound by the same emotions that we experience today; families then were, if anything, more closely knit than in our modern age. It is not surprising, therefore, that foreign photos that surface in this country after nearly a century or more are probably those of relatives who were left behind, having been brought by immigrants separated from their families by an ocean, a continent away from the old country and the secure home life they once knew. When you find foreign photographs containing unidentified faces that seem vaguely familiar to you, they are most likely those of relatives from the family's original

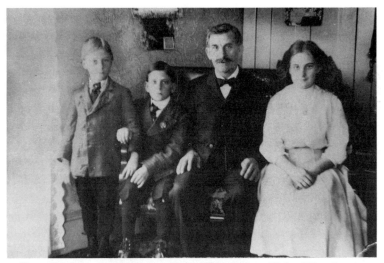

Figure 2.3. Taken around 1905 of Ludwig August Frisch and three of his five children at an age where they are easily recognizable. The daughter is only three years older than her brother on the far left, although the angle and full skirt make her appear bigger. Note the Victorian furnishings that serve as a clue.

homeland, or they even may be photos taken on foreign soil of those who did eventually come to America.

The closer you move to the present generation in your search, the more likely you are to find photographs of family members. Photos of children are some of the most common in family collections. Just as the birth of a first child today is sometimes heralded by a greater quantity of photos than of children born afterward, the same holds true for past genera-tions. In my collection, I have a large baby portrait of my great-grandparents' firstborn, a first-generation American child, and successively fewer and smaller photographs of their next four children (see figure 3.1).

Photos of people at work became increasingly popular in the 1920s and 1930s, when women emerged in the work force, and you may find among your grandfather's or grand-mother's collection snapshots of groups of coworkers and

"chums," as my grandmother referred to them, gathered outside factories and mills. In the West, mining photographs were taken from the 1860s on and are still fairly common finds today. If you know that your great-grandfather was a fireman, it is likely that his face will be among those of other firemen if you happen to find a photo of a group of firemen on duty.

Familiarization with the home addresses of your predecessors will also come in handy, especially those who lived near where you live. The less moving from state to state the family did, the more probable it is that photos will have survived from those earlier generations. Front porches and doorways were a favorite posing spot for amateur photographers. In a clear photo, you may be able to make out and match up the number of the house, perhaps painted over the doorway or hung on a column out front, with the street address of the same ancestor (see figure 3.7). If the photo was taken in the last hundred years, the house may still be standing, and you may want to pay a visit. While you can, take a snapshot of the dwelling to add to your collection, for even if the house has undergone changes over the years some of the original flavor will still be present.

The houses in which our ancestors lived, dined, held conversations, and made poignant decisions that were to affect the rest of their lives cannot help but be objects of fascination for their descendants. I was fortunate enough to be able to view the interior of the house my grandparents built when they first came to America, although it had been sold since; when the house went on the market again, a neighbor from the old days was able to borrow the key from the present owners to show me the house because she knew I would be interested. Unexpected and inspiring offers such as that add fuel to the fire of enthusiasm. Since opportunities like that

Figure 2.4. In the background note the architectural details on the church, which has remained the same for decades. It is easy to identify churches the family attended by finding where the marriages took place.

do not occur as often as we might wish, you must make the most of your opportunities wherever you find them.

Make a note on your worksheet of schools your ancestors attended and the education they received. While many of our predecessors, especially those of our grandparents' generation, had only a grade-school education and were forced out into the work place at an early age, those in later decades of this century were more likely to finish high school and attend college. It is possible that graduation photographs still exist for those individuals. Likewise, find out the churches attended and religions observed by your ancestors; places of worship were often used as the background for photos and are easily recognizable landmarks. Such pictures are commonly found in collections, their subjects posed on the church or school steps, and such a definitive backdrop can serve as a valid clue to identification (see figure 2.4).

Your worksheet should contain a sizable space for miscellaneous information, some of which can be the most significant genealogical data of all. This section might contain details regarding military service as photos taken in uniform or on board ships are fairly commonplace. An individual's military background can be a vital clue in identifying photographs. You should also include family customs and holiday traditions on your worksheet; many photos were taken in the home and are worth seeking out. Details such as knickknacks, room arrangements, wall decorations, and sofa, rug, and wallpaper patterns are all obvious associations for elderly relatives viewing the same scene in a photo today, years after they themselves were part of the original setting (see figure 2.5). Photographs of surroundings or environments where happy times were spent is a powerful visual stimulant to memory. Immigration information is also useful if it is available to you. The name of the ship, the year an ancestor sailed, and the general vicinity in which the family lived in their

Figure 2.5. Note the details of this interior. The photo contains three generations of relatives gathered at Christmas. The presence of the oldest and youngest is a clue to the photo's age. Not all those present are relatives.

former country are all important bits of evidence in the identification process. Knowing which relatives emigrated, along with the names of those who remained behind, can speed the process of elimination when trying to identify photographs.

Significant physical or facial characteristics are perhaps the most important clues you can obtain to help you ascertain the identity of subjects in photographs. Height, weight, piercing eyes, a full mustache and beard, or a particular piece of jewelry always worn by someone are all outstanding features that will help you distinguish one individual from another on different photographs. Specific identifying characteristics are the most important part of any description. The fact that my great-great-grandmother was part Narragansett Indian was a key factor in identifying photographs of her as she aged. Pictures taken in younger years showed no particularly pronounced Indian features. But compared with earlier

photos, her countenance became more markedly Indian in appearance as she aged, making her very easy to spot in group photographs or in single portrait views (see figure 2.6). Her mixed native American heritage was rarely referred to within the family circle as it was a source of embarrassment to the straight-laced Victorian generation. Her granddaughter remembers her indignant denial when she was falsely accused of coloring her hair to help it retain its naturally dark shade.

Anecdotes that reveal an ancestor's interests and personality are always valuable. Such information is rare and is usually available only from elderly family members who knew the individual in question and who recall stories about the person. You will want to record these recollections as your written record may be the only document in existence that recounts stories from the lives of those who have already passed on. Even if it seems implausible to you that your family is related to Abraham Lincoln, you should always investigate further to get to the source of the rumor. Such family "myths" are generally based on truth, even if all the facts are not readily available to you when you first hear the allegation.

I was always told that I was a descendant of a *Mayflower* passenger, though no relative knew for sure which passenger. It was an idea I never took seriously until I began tracing my genealogy and found the proof. The odds were in favor of the story being true since I remembered stories told by my great-aunt of taking the trolley with her aunt to a cemetery in Plymouth, Massachusetts, where the elusive *Mayflower* ancestor was buried; the connection was obviously genuine. Clearly, my ancestors were equally as interested in the lives of their forebears as I was in theirs.

A friend by the name of Todd, who had always heard that she was descended from the same branch of the Todd family as Mary Todd Lincoln, had little trouble tracing her roots back to Missouri and to the Todd family of the last century,

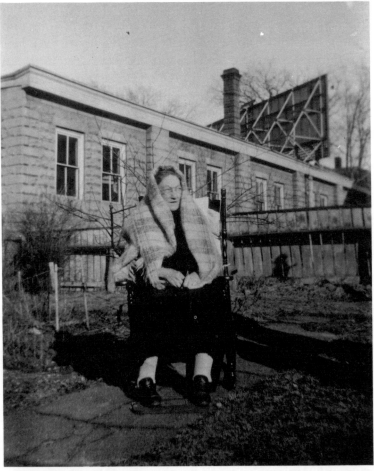

Figure 2.6. The facial appearance and naturally black hair of the author's great-great-grandmother, Isadora Drowne Cheek, made it impossible for her to deny her Indian heritage as she grew older. Taken about 1930.

even though the trail had woven from Colorado to Rhode Island over the course of time. The pride of another friend is that her grandmother was a cook in Ireland's Blarney Castle before coming to America. Such stories are captivating and usually true. Oral narratives often have the most impact in

terms of their importance to your genealogy because such fascinating information is not usually available in public documents.

Anecdotes from family members also reveal something about the psychology of our ancestors' era. My great-grandfather, it was rumored, had been a librarian in England before coming to America, a position of some importance in his time. This commonly held belief had its origins in wishful thinking rather than in actuality, however; we learned years later that in reality he had owned a pub in England. "The family lived near a library," our English cousins corrected us politely when we referred in all certainty to his vocation as a librarian. My great-grandmother left behind a life in Victorian England determined to begin another in a land where no one was acquainted with her or familiar with her background. Perceiving the clear advantage that distance had over a truth that only she knew, a truth that seemed to fade the further away she moved, she preferred not to admit that her husband had been a tavern owner and invented a better position for him. Viewed from a modern perspective that is less judgmental than that of previous ages, such behavior seems to have been fairly conventional among the women of her own day.

You might want to record your collected data in pencil until your information is verified at the city hall or library. Often, vital statistics (birth, death, and marriage records) were kept individually by each city or town from the time the earliest settlers arrived, and they are still kept separately today. Indexes exist for most of these records to make the search easier for anyone looking for a particular piece of information. Write or call your state capital for information if you are not certain where the records you want are located; the state capital is often used as a central depository for all state records. There is usually a nominal fee for copies of such documents. The charge generally ranges from two to five

dollars for a single copy of a birth, death, or marriage certificate, but a copy is not necessary if you are keeping good records and are only confirming what you have already learned from a relative. In a smaller city or town hall, you can often view the original public records, usually in the handwriting of the town clerk at the time, with the use of indexes to direct you to the correct volume.

A public library may also have indexes to vital statistics records for births, deaths, and marriages that occurred within a community where you can confirm the information given you by relatives. At a public library, you will probably be able to obtain such information free of charge, and you are often able to make notes while checking these documents. On a visit to Scotland several years ago, I made a point to visit the New Register House in Edinburgh, where vital statistics records are kept from 1855 to the present for all of Scotland. I had brought a notebook with me to record all the information I could possibly collect in the two hours or so I had allotted away from my scheduled tour. Records officials were most cooperative in helping me locate the records I needed, but they were also most emphatic that notes be taken in pencil. For those researchers who arrived with only a pen, lead pencils were sold at the main desk. It is important to remember and to respect the age of the documents that you will be handling in your search.

From your completed worksheets, you can see at a glance if any information is missing. With these worksheets, you are able to assess your notes as you go along, in quiet moments that are free from distraction. This is an important step, for the information you need to know will change with the addition of any new leads, depending on the facts you collect. You may find, in fact, that after compiling pages of information, you are still lacking a crucial piece of information, perhaps a forgotten date of death, for instance. Discoveries

that you make in speaking spontaneously with relatives will prompt you to inquire about other issues as well. If you unexpectedly learn, for instance, that your family lived in another state beginning with those in your great-grandfather's generation, you will want to trace the family back through that earlier location as far as you can go.

Much of the time you will be combining facts that have been gathered at separate times; therefore it is important that the statistics you collect from relatives are true. When dealing with memory, there is always room for error that has nothing to do with age. Well intentioned as it might be, information that you receive from family members should be verified for accuracy through public records. These facts, dry as they are, become increasingly significant if there is no one left alive to give you the information you need. Many anecdotes and answers that have died with our ancestors are regrettably lost to us forever, leaving us dependent upon public records. Dates of birth, death, and marriage from city or town hall records in the locale where the events occurred may become a crucial ally as they may be your only clue to identifying old photographs.

Other clues you may pick up from relatives are equally as important as facts from vital statistics records. In a letter from a great-aunt who lived out of state, I found key information I would not have been able to locate elsewhere—the fact that when my great-grandmother was three years old, her mother had died in Germany. Such information never crossed the ocean in writing but only by verbal transmission; fortunately, marriage records in this country that include parents' names usually also indicate when an individual is deceased. The letter also stated that my great-grandmother, my great-aunt's mother, had arrived in America with her father in 1882. Shortly before the letter arrived, I had discovered a small photograph, in an album belonging to my great-

grandmother, which was taken in Germany of a woman in Victorian dress. I can safely surmise that the photograph is most likely a picture of her own mother, a photograph treasured and brought from the old country when she came to America with her father to begin a new life. Although the evidence will remain inconclusive until new information comes to light, the odds still favor the assumption that the photograph is of my great-great-grandmother because of the subject's age and the fact that there were no sisters in the family.

Keep a notepad handy for casual meetings and family functions at which you will have an opportunity to keep the lines of communication open. If you see your relatives casually when not formally interviewing them, your very presence may jog their memory and inspire spontaneous, long buried memories to come to the surface. Once your relatives know that you enjoy hearing their stories, they will be more encouraged to talk openly about their family experiences and recollections.

The ideal source of information is, of course, a family reunion, where a number of relatives gathered together cannot help but reminisce freely, thereby prompting other nearly forgotten stories to come to light again. At such a time, contradictory anecdotes may be openly debated and refuted as well, hopefully until an accurate conclusion is reached. If you are fortunate enough to belong to a family that has planned an upcoming reunion, do not attend without your camera and a notebook. Such an occasion provides the perfect opportunity for you to collect your own photographs for posterity. While the identities are fresh in your mind, always label all photos promptly with both the identities of the subjects and the date. Learn from your ancestors' mistakes! I have found it difficult to go back and date childhood photographs of myself and my brothers, and those are photos

from this century, from the 1950s and 1960s—not nearly as old as the majority of those you will likely be trying to identify. Providing the service of maintaining accurate family records and identifying photographs indicates to the world that you are doing your own part for posterity and for future generations who will be as interested as yourself in finding out who their ancestors were.

Spread the word openly among your family of your interest in its background. As word travels, you will rapidly develop a reputation as the family historian. In the course of your research, you will imperceptibly but gradually become the expert who will be able, upon finding photographs of ancestors, to identify the subjects for the benefit of others in your family.

3. DATING PHOTOGRAPHS: CLUES TO IDENTIFICATION

It has been well established that while you are tracing your ancestry you will always be at the mercy of time. Sometimes you will find that even with prompt action on your part in collecting genealogical data you will still be a victim of your own heritage—your photographs may be from another side of the family than that which you already recognize, you may simply have no great-aunts or grandparents left alive to ask for information, or those who are alive will not have the answers you need. When you reach such a discouraging point, you must turn to an analysis of the photographs themselves to study the clues within.

When you present photographs to relatives for identification purposes, you will be confronted with one of two situations. Your relatives either will or will not recognize the faces in the photos. A third alternative presents itself if they identify a snapshot incorrectly, preferring to hazard a guess to satisfy your curiosity so as not to disappoint you. However, with careful comparisons with photos that have already been identified, after awhile you will be able to spot inaccuracies or false identifications and make the necessary corrections.

If relatives are able to identify photographs for you, your immediate mission will have been accomplished. If they are

not able to identify them, you will be forced to use your own powers of deduction and put together clues to aid in identification. One of the most effective forms of assistance is to date the photos in question.

If you find that you must assign an approximate date to a photo before you can identify it, you will discover that you may at least be able to ascertain the generation of the subjects in the photo, which will help you significantly later on. If you are familiar enough by now with your family's genealogy to know the birth dates of its various members, you may be able to judge that the subject is too old to be your grandfather, for example, though it may well be a picture of his father. If your photograph is decidedly Victorian, and you know that your great-grandfather was born in 1860 while his son (your grandfather) was not born until 1898, a photo of an adult male taken before the turn of the century cannot possibly be that of your grandfather. Through your knowledge of birth dates and other events in your family, the process of elimination will become your best common-sense ally in your search to identify ancestral photographs.

If you are trying to identify a studio photograph, and you live in the same area where the photograph was taken, you will probably have access to information about the particular studio, which will help you pin down the date. If you live in another part of the country, you can write for the same information. Never feel that you are at a loss for information simply because you live a great distance from where your ancestors lived. You are never, after all, more than a few generations away from them.

Many of the Victorian studio photographs, called cabinet photos or cartes-de-visite, depending on the size, are a century old and are frequently printed with the name of the local photography studio where the picture was taken. These photos are recognizable by their warm sepia or sometimes

charcoal tones, and the thin photo is mounted on a cardboard backing for protection. It is on this cardboard mount that you will find the name and address of the studio embossed or printed (see figure 3.1). Not only is the studio an indication of the photo's approximate age, but it also gives an idea of the year an ancestor may have come to America; if nothing else, it certainly confirms that an ancestor had reached America within a certain period of years. The reference librarian at your local library will be able to explain to you how to find out when a studio went out of business, and chapter 4 will also deal with the subject. This is a fairly simple method of assigning an approximate date to your photographs.

An address can also provide you with nearly correct dates for photographs in your collection. By tracing the years in which a studio remained in business at a certain address, you can figure out roughly when your photos were taken and settle the question of the age of the photo once and for all. Brown Studio, for instance, may have been located at 65 North Main Street until 1893 when it moved to a new location. One of the addresses you find for the studio will correspond to the street name printed on your photograph. Discovering how long a studio remained at a given address will provide you with a time span to help you narrow down the age of your photograph. (Occasionally, street numbers were reassigned in some locations so that a studio listed at 65 North Main Street in a certain town will suddenly change to 77 North Main Street, even though the studio did not actually change its location.) You may come across several photographs from the same generation taken around the same time at one studio.

Public libraries can provide a wealth of instant and usually free information through city directories. Volumes are published annually even today, which list all residents and

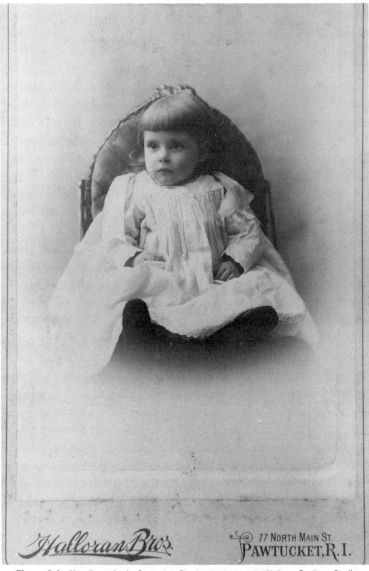

Figure 3.1. City directories for Pawtucket, Rhode Island, show that Halloran Brothers Studio was no longer in business at 77 North Main Street after 1899. A baby portrait such as this would have been difficult to identify but for the fact that an identical larger portrait was recognized as my grandfather's oldest sister, Henrietta Frisch Johnson, born in 1892.

businesses in individual towns. The volume is a more detailed breakdown than the census collections compiled in earlier centuries. If the information you need is to be found in a library some distance away, a telephone call or inquiry by mail will tell you if the library contains the city directory you seek. Many eastern states kept city directories from the early 1800s on. If you inquire by mail, be sure to include a stamped, self-addressed envelope for the convenience of the librarian and explain clearly that you wish to know what years a particular photography studio was in business. If you are not familiar with the area, you can locate the library nearest the studio listed on the photo by first consulting a map and then checking in the telephone directories of your local library.

Often, it may be easier to figure out the date of a photograph before you learn its identity. If you know that your great-aunt Lavinia was born in 1889, and the address on the photo mount is from around 1882, then you can be sure that she is not the subject of the photo. The same holds true for foreign photographs. A clear, accurate knowledge of an ancestor's arrival in America can rule out the possibility of another ancestor being incorrectly identified. For example a photo taken in America around 1885 cannot possibly be that of an ancestor who did not arrive until 1900. Your study of old photographs will often consist of utilizing the process of elimination in this fashion. You will need to cultivate an intimate familiarity with the dates your ancestors lived and died and then build on the storehouse of knowledge that you have compiled to identify photos with any degree of success.

Even when you have identified your photographs you will still probably wish to date them as the date is an important and major clue. Once you have figured out to which generation a photograph belongs, it will be easier to find an identity to go with it. You are dating photographs for more than the sake of curiosity; the approximate year a photo was taken can

be one of the most helpful clues to identification and is sometimes the only clue.

With family photographs not identifiable by the studio's imprint, you may still be able to assign an approximate date to the photos using your powers of deduction. Surviving wedding portraits from the early decades of this century, for example, usually include at least the maid of honor and best man along with the bride and groom (see figure 3.2). The element of luck is on your side in this instance for tradition played a strong role in the lives of those of former generations—usually a single bridesmaid was a sister or cousin of the bride. If you know the identity of either the bride or groom, it will be fairly easy to obtain the identities of the other parties by checking the marriage records at the city or town hall in the community where the event occurred. Although the specific contents of records vary widely from state to state, you may find that witnesses were listed on the marriage certificate within the time period you seek. If nothing else, you will be able to verify the date of the event.

If you find yourself consumed with curiosity at odd hours when your local library is closed and the information you need is temporarily unavailable, again, your own powers of deduction should not be overlooked or minimized. Other clues that can help you determine the date a photograph was taken, which will in turn help you ascertain which generation the photo is from, are styles of dress and clothing design. Tall hats and bustles on women, often photographed from the waist up, are generally found before the turn of the century and are from an earlier generation than head and shoulder three-quarter or profile views of women with upswept hair and a white drape or fabric mantle arranged over the shoulder (see figure 3.3). Full views of subjects in formal dress with one figure seated and the other standing are from a

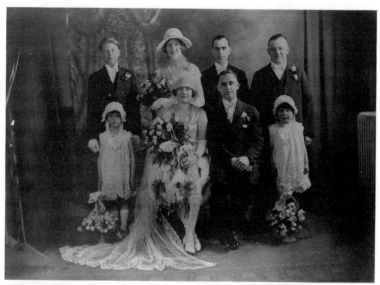

Figure 3.2. A wedding photo from March 5, 1927, containing several family members. The maid of honor was the sister of the bride and the best man was the brother of the groom, and both are listed in the marriage record.

much earlier period, some as early as the 1860s and 1870s (see figure 3.4). The more casual, unposed, spontaneous photos came later, after the turn of the century, and are fairly common in more recent collections as more individuals enjoyed the opportunity to own a camera.

Check the styles of old automobiles in photos and look carefully to see if there is a state or year on the license plate of the car. A magnifying glass may be necessary for examining detail and preventing eye strain. Close inspection of snapshots will reveal additional details that can serve as clues in your research, particularly in photos taken in the home where relatives would be likely to recognize a household detail that someone from a later generation like yourself might overlook. The more you thoroughly familiarize yourself with old photos, especially those taken at home, the more

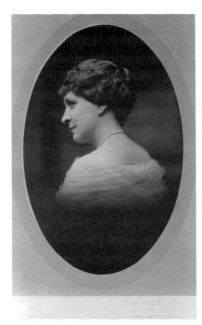

Figure 3.3. Louisa Barnes Sullivan (1886–1970). The style of a photo reveals a great deal about the date taken. Notice the props used with the women.

knowledgeable you will be about different historical periods and the more skilled you will become at recognizing various family possessions that often turn out to be prominent clues.

Familiar landmarks are another source of determining age. Consult old newspapers on microfilm at the library for a positive identification of particular landmarks such as statues, bridges, and towers. Make a careful note of conspicuous landmarks in the areas in which your ancestors lived and learn the territory so that you will recognize the same landscape the next time it appears in a photograph. Your local historical society may also be able to identify photographs that contain views of town monuments and other structures that will help in ascertaining age (see chapter 4 for more detailed information on sources), and they may also know when particular landmarks were erected. Remember that you must actively look for clues that can help you in your search even while soliciting assistance from others, for it is multiple clues that eventually lead to solid evidence.

Matching these dated, time-related clues to family members of the same age and generation will give you the approximate decade in which a photograph was taken. Well-documented information collected from relatives and recorded in an

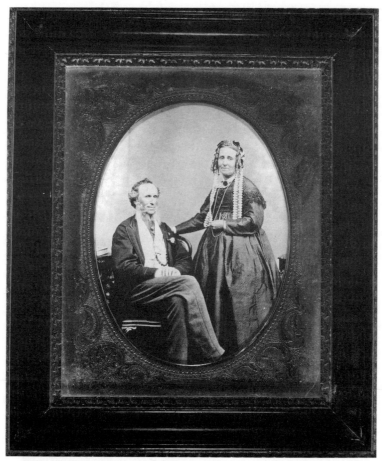

Figure 3.4. Clothing styles are a clue to the age of a photo, especially in formal portraits. Also, note the brass mat is similar to that of a daguerreotype.

organized chart, like the one suggested in chapter 2, will aid you now in your endeavor. There are numerous other clues you will want to pursue beginning with family resemblances. Here is the chance for you to make use of your skills of recognition by scrutinizing facial features such as eyes, nose, mouth, shape and size of ears and chin, and other

distinguishing marks. Collect, borrow, and compare as many photographs as possible of your ancestors while trying to identify photos. Some faces can seem to take on a different appearance from one photograph to the next.

Also, consider the arrangement of pictures carefully, particularly if the photos you are studying are in an album. The placement of snapshots in albums is usually not haphazard but quite deliberate and is often done in chronological order just as they were taken. Portraits that are side by side in an album frequently turn out to be husband and wife or brother and sister. Photographs that have been well preserved in albums are a treasure as well as a pleasure to find. A legacy from another day, photographs remind us that others before us cared enough to go to the trouble of assembling their own collection at some point in time, just as you should do with your own favorite photos. If your photos are still in a shoebox waiting to be put into albums, you would be wise to at least write the names of the subjects on the back along with the years until the photos can be attended to properly.

Your most substantial clues will inevitably be derived from the photographs themselves. Let the photos provide you with grist for the mill of imagination and recollection. In a series of photos taken a decade before I was born, I saw furniture that looked familiar even to me. Although I did not know all of the people in the photos, I recognized the pattern of the sofa (see figure 3.5). Many old, handmade lace doilies in my possession that had been preserved in my grandmother's hope chest for nearly twenty years also appeared in the photos. Because I knew from which side of the family the doilies had been handed down, I had a major clue as to the identity of individuals in the photos. The doilies had become almost as much of a trademark of the aunts who had crocheted them as cats and roses had been for other branches of the family.

Figure 3.5. Internal clues are helpful in identifying interiors. The distinctive sofa and rug patterns and table decorations are easily recognizable even if only a small area is visible.

You can indeed learn of your ancestors' interests and concerns through their photographs. Snapshots of summer gardens, beaches, picnics, and parades indicate outdoor events in which they probably participated. Pictures of summer activities especially tend to be more plentiful, particularly in colder climates. Photographs taken in front of churches also reveal insights into their lives. Church pictures are usually taken of persons in their Sunday finery, wearing outfits that would likely be remembered by others in the family. Consult your worksheets to see which ancestors attended churches that might be recognizable to someone living in the vicinity. Youngsters graduating from the church's nursery school or Sunday school class often had their pictures taken on the church steps—among family relics you could very well find banners announcing such graduations. The identity of the church takes on a special significance when you know which

individuals in your family attended worship services there. Watch also for photos of church picnics that contain a number of people.

In going through old family papers, be on the lookout for letters and postcards that might reveal locations or destinations of family members who traveled at one time. Snapshots taken on vacation are more likely to be identified with at least the location, if not the date or names of the people in the shot, than photos that capture everyday activities. Even if you have not come across vacation photos, save letters that relate accounts of traveling. Sooner or later photographs are likely to show up from such a trip. It is even possible that you will find photographs of places you have visited that contain the same views you took with your own camera. History does seem to repeat itself curiously within families. After I had taken color snapshots of the statue of Evangeline at Grand Pre in Nova Scotia, I later found similar black-and-white photographs taken by members of my family over thirty years earlier that contained the exact same views.

A considerable number of photos in family collections tend to have been taken in connection with funerals, often with family members standing beside the newly erected gravestone. These are of value in that the carved inscription will specify the year and provide a dependable method of dating other individuals in the photo if you know their birth dates. The obvious advantage of such a photo is that it is already dated for you. A clear photograph of a flower-laden grave in a cemetery helped me to locate the spot forty-five years later. The grave had remained unmarked during that time, yet I was able to find the area by the design of the headstones around it.

There are other items that you will be likely to find as you search through boxes of family remnants that may or may not

contain photos. Advertising cards from the early years of this century are a possible indication of the age of other artifacts packed at the same time. Wedding invitations may be useful for learning about relatives who lived out of state—an invitation will give the date, names, and other information about the participants. I have found a number of laminated memorial obituaries from funeral homes. One contained a permanent record of the obituary and funeral details on one side while the reverse side featured the Twenty-third Psalm.

In your analysis of photographs, look particularly for photos that might be dated indirectly or that might contain subtle clues. Wedding portraits, as previously mentioned, are useful because even if the identity of only one party is known, the date as well as additional information can be traced easily through public records. Graduation portraits or other high school snapshots from the 1940s and 1950s often contain the year somewhere within the picture or an initial on a sweater that can be a significant clue in determining identity. Casual snapshots taken at high school graduations or other events may be indicative not only of the year but also of the month and can therefore be dated that much more precisely. In the early decades of this century, graduation from junior high school and even grammar school was celebrated as a remarkable achievement more than it is today simply because fewer students were able to receive an eighth-grade education. Often, children were forced to work in mills or factories due to the financial needs of their families before reaching the age of graduation. Many photographs were taken on such an occasion (see figure 3.6). Check the birth dates of earlier-generation family members carefully when you find a photo of someone with a diploma in hand.

Be careful not to overlook the obvious. Depending on the customs of the company that developed them, photographs

Figure 3.6. Being able to recognize the subject and knowing that she was born in 1909 helped me to estimate the year this photo was taken to be around 1923.

from the 1950s and 1960s in particular were sometimes automatically printed with the date on the back. I found two casual snapshots taken by amateur photographers that were identified by the photo service that developed them from negatives as early as 1937 and again in 1943. This is a delightful discovery to make since more often than not our ancestors did not bother to write the dates on photographs.

While photos of babies are the most difficult to identify, pictures of children in the process of growing are sometimes the easiest because their ages can often be determined within a couple of years. A careful guess as to the ages of children in a photo and the year the photo was taken, combined with a knowledge of birth dates, can leave you well equipped to figure out the identities of the subjects. Christmas and holiday photographs offer an entirely different and more encouraging set of clues. The task is simpler if there are several children pictured beneath the Christmas tree; most likely they are all of the same family, and it will not be hard to decide which child is which in relation to one another if you know the birth dates of family members. Keep your eyes open for the type of photographic Christmas cards that are still produced today for the proud parents to send to relatives and friends; they were used as early as the 1950s.

Figure 3.7. Doorways were a popular spot for photographs. Often the street number of a house is clearly visible in photos, as is the "174" here, and can be matched up to a family's address through city directories.

76

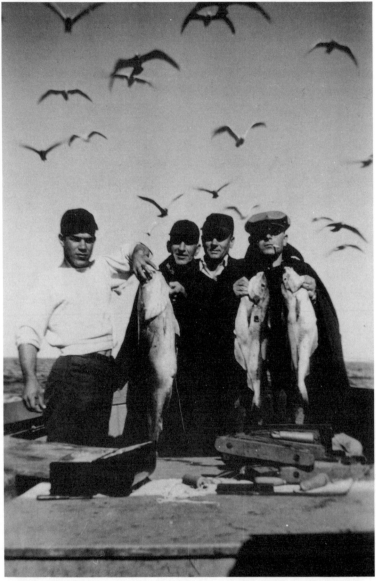

Figure 3.8. Although only one of the four men is a relative, family members instantly recognized him at his favorite pastime. Even in shadow, the faces are still clear. Taken in September 1941.

One advantage in having such photo souvenirs and holiday mementos is that you already know the month in which the picture was taken. The task is then to figure out the year from the size of the children.

Again, armed with a written knowledge and background of your family, you cannot help but succeed. The information you have collected up to this point and recorded so carefully on worksheets will be your most valuable asset when examining photographs for clues. Notes on the addresses, occupations, and hobbies of individual relatives will play quite a revealing role when you come across a picture taken in the ever-popular doorway with the number of the house printed clearly above a relative's head or a snapshot of your cousin's grandfather engaged in his favorite sport—proudly holding a fishing pole attached to the largest striped bass ever caught in the lake up north where your cousins always went for summer vacation. The stronger your knowledge of family traditions is, the better your chances will be of correctly identifying individuals in photos (see figures 3.7 and 3.8).

Photographs from other countries pose a special difficulty in identification because relatives who never came to America are only officially mentioned in marriage and death records of children who did emigrate, and only if those children married or died in America. Other than public records, you must depend on private records kept by the family, such as letters or diaries, which are usually lost or destroyed over the years before they ever have a chance to reach an interested party like yourself. Family Bibles at least have a better chance of survival. If an ancestor was born in another country but married in the United States, the parents' names would be listed in the marriage record (provided it was the customary procedure at the records office in the town in which the marriage took place; such information was generally recorded after the turn of the century). This information is

usually the most accurate available because the names are given by the daughter or son of the relative who remained in the old country and whose photo you hope to identify.

Often photographs that traveled to America with immigrants are the only surviving pictures in this country of ancestors who did not make the journey with their offspring. Immigrants from other countries brought so few items with them you can almost be assured that an old foreign photo is that of a relative. Although broad assumptions are not conclusive or even necessarily recommended, in this case it is a fairly safe guess. If your lineage is mixed, with ancestors from a number of countries, foreign photos are especially helpful in determining identity as they can easily rule out several branches of the family at once. Barring unusual circumstances, a photograph of an unrecognizable individual taken in England is not likely to be that of your great-grandmother who emigrated from Poland. On the other hand, foreign photographs sent to relatives or friends who have already immigrated to America tend to contain more information; often the sender will have included a brief note on the back of the picture as to its subject, date, or occasion (see figure 3.9).

In any identification endeavor, luck necessarily plays as large a part in your eventual success as skill does; fortune favors those whose ancestors were sentimental enough to save old photos rather than discard them through the years. The single photograph that survived from my grandmother's Scottish past, other than those that were sent to America later from relatives left behind, is a small yet formal and elegant family portrait of herself, her sister and brother, and their parents taken in a Glasgow studio that she gave to me when I was young (see figure 1.4). Even then she had no overwhelming desire to keep it for sentimental reasons as matters of a more practical nature took precedence in her home.

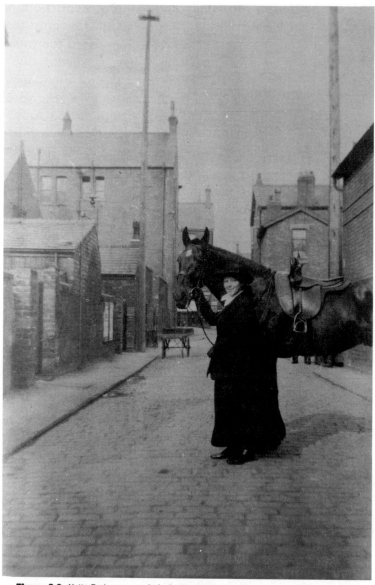

Figure 3.9. Netta Rodger, a cousin in Scotland, sent this photo to her favorite "chum" in America, taken around 1912 while she was at boarding school. Note the cobblestones and old-style charm of the architecture.

Identification of old family photographs will, if nothing else, give you a sense of history and location. Once ancestors arrived on the east coast of America, they often continued their journey westward, perhaps leaving relatives halfway across the continent or farther in their quest for a new life in the land of opportunity. If while talking to a relative in Massachusetts, you learn that one side of the family moved to California thirty or forty years ago, it is likely that somewhere within your family's collection of photographs a few snapshots exist containing a backdrop that will be recognizable as that of California. You should always be on the lookout for pictures like these. Even if the move was made many years or, possibly, decades ago, and close relations no longer exist between your end of the family and the California branch, it is very possible that someone from the family of an earlier generation made a cross-country visit and undoubtedly took what may be the only photographs in existence of the western branch of the family to bring back east. Photographs from states other than your own that feature dramatic differences in architecture and landscape contain obvious clues to identity, often with distinguishable landmarks that indicate precisely where a picture was taken.

Examine carefully all other photographs to which you have access for clues. A thorough knowledge of particular facial characteristics belonging to different family lines will enable you to recognize at a glance to what branch of the family unidentified faces belong. Having a variety of photographs to study and scrutinize brings out many features of your family that you might otherwise miss and lets you see how resemblances develop over time. You will have made a strong start if you can at least figure out to which side of the family a given likeness belongs, even if you are not immediately able to identify the specific individual by name. Watch for familiar elements that continually appear in snapshots; cats figure so

prominently in photographs from one side of my family that I fully expected to find a cat on the family coat of arms. Such trademarks reveal insights into the lives of our predecessors. I found a number of photos of female relatives from the past and present standing by the back fence in the same yard holding a goldfish bowl with a cat in it (only the aunts and cats changed from year to year; the pose never varied much). You may be able to relate such photos to other artifacts you find that once belonged to your ancestors. Besides photos of unidentified cats from another age, I found feline doorstops, salt-and-pepper shakers, prints, and similar household items packed away, all depicting cats. Some objects may appear so often that they seem to be family emblems of a sort, but they might actually indicate which family took the photos and thereby serve as a clue for you.

Notice houses, both interiors and exteriors, that appear in a number of photographs. Chances are that such dwellings are or were family residences and may register in the memory of a relative who might have visited them at one time. Observe particular houses that are visible in a number of photos, even if the house is located in the next yard and is discernible only in the background. Architectural details on houses from the latter decades of the last century and the early years of this one are especially noticeable and tend to be easy to spot from picture to picture. Most people are quick to recognize house exteriors and street scenes that are both conspicuous and memorable to someone who once lived in the neighborhood. Look closely at the backgrounds of interior photographs; often you will see framed photographs on the top of a piano, on a side table, or on a wall. A photograph within a photograph can also give you a substantial clue!

Check also such items as old cards and letters tucked away in family Bibles and even your mother's or grandmother's recipe box for penmanship styles that might match

handwriting on the backs of photos that perhaps give locations but no identities. Individual signatures and styles of penmanship also appear in wedding and funeral home registry books, old grammar school report cards requiring a parent's signature, and greeting cards from special anniversaries or holidays.

One of the most effective methods of identifying photographs is to analyze them and do your research based on what you see (or do not see) in the photos. Combined pieces of information can provide worthwhile clues to dating. Types of film, cameras, particular techniques used, and styles of dress are all significant as are other details of the period in which your ancestors lived. Particularly useful is a detailed working knowledge of the history of the area including architecture, transportation, manufacturing processes, firearms, and other elements of the daily life of the time. Using such information to help you solve your own mysteries can sometimes narrow the possible date of a photo to within a ten-year period.

Before you take the trouble to go through public records, do your homework thoroughly. Study photographs carefully to absorb as much as you can from them and to get a feel for their subject. While you look for clues, rely on your records. Remember, you are keeping them to provide you with answers in times such as this when you find yourself puzzling over a group picture of five individuals who resemble one another and are obviously a family unit—but whose family? Your notes should serve as a source of clues as well as a guide.

Let photographs tell their own story. The familiar scene of a family gathered outside a house might mark a particular occasion such as a holiday or a move into a new home, but you will not know their identity for sure until you combine the knowledge you have acquired with small bits of evidence collected over time. Identifying photos can be a time-

consuming process of trial and error resulting in discoveries made from an accumulation of facts and educated assumptions. A detailed knowledge of family information in addition to a careful examination of city maps, landmarks, and architecture will provide you with unexpected clues. Many suppositions held for long periods of time eventually become facts by bearing up under the scrutiny of other pieces of confirmed information. In many cases, your final proof will be pieced together over time, resulting in an identity built from fragmented clues gleaned from family knowledge or beliefs substantiated by public records and from the photos themselves.

Whether you are trying to identify a formal portrait or a snapshot, each has its value. While studio portraits taken under ideal conditions with manipulated lighting are clear and distinct, casual snapshots taken by an amateur are often easier to identify because they contain external clues. Fortunately for our generation, sentiment has prohibited the disposal of many of these photos that might not have survived otherwise, although many ended up relegated to the cellar or attic. The fact that they were neglected for years rather than destroyed is, ironically, one of the reasons why so many are still in existence today.

4. PUBLIC SOURCES OF INFORMATION

The first three chapters of this book have concentrated on methods of identifying family photographs from assistance received from within the family unit. Such a source of information is the ideal beginning to your search, provided that it is supplemented with facts verified through public records. For those without relatives to ask, however, or those with relatives whose memories are failing too severely to be reliable, public records may be the only source of information available. The advantage of public documents is that elusive answers that cannot be found in one place are often available in another. You have at your disposal a wealth of accessible records whose importance lies in their precision. Once you begin to investigate the realm of public records, you will find more information open to you than you realized or expected.

Vital Statistics

In New England vital statistics records have been kept from the time the first settlers arrived. Those whose ancestors passed through New England between the mid-1600s and today, settling there or elsewhere, are likely to find information. These records tend to be readily accessible and are for the most part complete. Vital statistics are the most necessary

information you can collect about your ancestors for the purposes of photograph identification. Birth, death, and marriage records will tell you the exact age of all members of your family without your having to rely on anyone's recollections. City and town halls also keep indexes to vital statistics in order to facilitate locating individual documents with ease.

The three types of records contain different information, and their value to you will depend upon the information you are seeking. Although the content of vital statistics records varies from state to state and has changed much over the course of time, birth certificates generally will provide you with the full name, birth date, and birthplace of the child; the names, ages, address, and occasionally the occupations of the parents; and sometimes the number of other children in the family.

The death certificate reveals a great deal of information about the life of the deceased because it is the last public record filed on an individual (see figure 4.1). It will usually list the date, place, and cause of death; age (often including months and days); parents' names, a particularly valuable piece of information for someone born and wed in another country who would leave no other record of parents; birthplace, if known; address; and occupation. The family member filing the death record gives whatever information is known, but after many years in a second country, parents may not often refer to the original homeland in the presence of their children. Sons and daughters of immigrants sometimes know surprisingly little about their parents' lives in the old country. Personal details about the life of the deceased on some death records are more specific than on others, depending on the informant's knowledge of the subject; some, for instance, give the exact town or locale in a foreign land where an ancestor was born, information that is

Figure 4.1. Filled out by a modern-day clerk, this copy of a death certificate from Providence, Rhode Island, in 1874 reflects information included. The mother's name was actually Phoebe. Note the cause of death: "Run over by car." The deceased was a railroad brakeman.

particularly valuable to the individual's descendants who were born in America and might know only the country of origin.

Marriage certificates are useful because they tell a great deal of information about two individuals rather than one (see

Figure 4.2. A marriage certificate in England in 1855 included many specifics, even father's trade.

figure 4.2). These records will supply you with the names of the bride and groom and the date and place of the wedding along with the name of the presiding official; their ages, addresses, and often their occupations; names of the four parents, whether they are living or dead; the number of times the wedding participants have been married previously; and occasionally the names of witnesses. Marriage records are generally the most accurate because the information in them was given by the individual participants who knew for certain the answers to the questions asked, provided they had no reason to conceal the truth.

A word to the wise regarding vital statistics records, however; they are not always necessarily correct. On my great-grandmother's death certificate, her own father was incorrectly listed as Raymond Schaffer when the name should have been Richmond Schaffer. The information was given after her death by her daughter who had never known her grandfather. The only reason I knew the correct name was because I had checked the marriage record first before I consulted the death record and found that my great-grandmother had listed her father as Richmond. It is

important to get as close to the source as possible. In this case, the information on the marriage certificate would be more reliable because his own daughter would have been the one to give the information. Always remember that the information on vital statistics records is only as accurate as the informant's memory. When discrepancies occur, they are often due to an error in memory on the part of the individual providing the information.

Memory error is the major pitfall with public records and obituaries. The "facts" you read in a newspaper obituary, even if written from information provided by a family member, are not carved in stone. Even when information *is* carved in stone, as it is on a tombstone, it is not necessarily accurate simply because it is written there. My grandmother's date of birth was incorrectly carved on her headstone as 1902 when it should have read 1901. Such misleading information can become a common belief within the family long before the mistake is ever realized.

With the passage of time the word of a family member might not be believed over that of a public record, yet in this situation further inquiry proved memory correct, as will sometimes be the case. Always be open to new information you pick up by accident, even if it is contradictory to what you already believe. Investigate both theories until one proves true and one no longer holds up in the light of new facts. Consult more than one source before you allow yourself to be convinced of the accuracy of any fact. Once you verify known elements, your search will be easier.

City Directories

City directories can be of tremendous assistance to you in your search to identify photographs of ancestors as they can provide you with names of children born into certain households over a span of years. These directories are

published annually by nearly every town and city in America and have been kept since most communities had their beginnings. Their value lies in their capacity to trace heads of families and employed individuals within those households for the duration of their lives within a particular community. These directories are essentially a more detailed version of our country's original census records.

City directories will often give you the name and address of the head of the household, all adult family members residing there who are working, and their occupations and places of employment. Again, content varies with location. Most importantly, the directory recognizes the presence of individuals within the household; the mere listing of members of different generations living under one roof confirms some relation between them, most likely though not always that of parent and child. Through city directories you can trace the patterns of your ancestors' lives almost without ever consulting another record; if volumes exist for the duration of the lives of those individuals you are tracing (see figure 4.3).

The publication tells when and where a family relocated, whether to another town, state, or even another country. You can follow them from one location to another as they move from street to street within the same neighborhood or to another town or state. The only major drawback of city directories is that they fail to acknowledge the presence of women not employed outside the home, a statistic that accounted for the vast majority of Victorian wives; women who worked as domestics in the homes of others were also excluded from the listings.

Even if children in the family were born while the family was living in another town, a quick check in the city directory will reveal all individuals in the household, related or not, as they come of working age. Along with residences, city

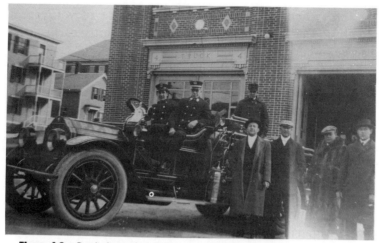

Figure 4.3. Despite its physical defects, a photo like this is valuable. When you know an ancestor's occupation from a city directory and you have other pictures of that individual, it is possible to guess who is at the wheel of this early twentieth-century fire engine.

directories also list businesses and offer the best way to determine the dates in which a photography studio was in business at a given location.

In terms of identifying photographs, it is important to ascertain the town in which your ancestors lived. If you locate a photo of an individual that was taken in St. Louis, and you know for certain that a particular ancestor spent her entire life in Massachusetts, the process of elimination tells you that the photo is not of that person, barring the possibility that the portrait was taken on a visit there.

Dating a photograph by the studio where it was printed will tell you two important things: it will give you at the very least a rough estimate of how old the picture might be, and it will confirm the fact that an ancestor who originally came from another country was in America by the date the studio was in business at the location mentioned on the photo. If your great-grandmother arrived in the United States in 1882, and the studio that produced a certain portrait was out of business

by 1881, then either the photo is not that of your great-grandmother or else she arrived in the country earlier than you believed. More likely it is not her.

The greatest value of the city directory lies in its quality of preserving some trace of the lifestyles and movements of our ancestors. Cold factual dates learned from vital statistics records seem less important and somehow more trivial and mundane when one can learn so much more about an ancestor's life. City directories are perfect examples of how a previously nameless and perhaps faceless ancestor becomes a person with vivid, distinct characteristics. I discovered, for instance, that a great-aunt who had passed away several years after I began my research had been a nurse in the 1920s. Even when I asked her about our family's past, that she was a nurse was somehow overlooked. While some relatives were surprised by the news, others knew of her early vocation. Although their remembrance of it confirmed the fact for me, and they were even able to relate some of her experiences as a nurse, such information had been forgotten by other family members who certainly knew of it at one time. Another value of the public record is that it prompts the memory.

Among the photographs in my great-grandmother's Victorian album is a portrait of an unfamiliar man with the name Theodore Goerlitz conveniently written across the back, information which is particularly helpful because no other mention of his name exists among family documents. He did not marry into the family or live within the household, nor was he a distant cousin. He seems to have been a close friend to the family at the time, an individual who took on meaning only when I traced his existence through the city directories hoping for a clue to his significance in the family unit. Formerly just a name and face in a photograph, he now became a dyer who lived at the corner of Pine and Cross in the city where the rest of the family lived. I took a guess and

started tracing his name in a city directory from 1888 to find that he made his first appearance in 1886 and had "removed to Germany" in 1891. In another instance, I watched an ancestor turn from iceman to grocer to liquor dealer. In tracing families through city directories, as you follow a particular line from year to year, you will see the gradual appearance of children within the household as they come of age and thereby confirm their relationship within the family.

Various facets of your research will begin to tie in and make sense as you trace the lives of your ancestors in city directories. As I read about my great-grandfather's sister Ernestine, her husband Fritz, and their family, I remembered family stories of my grandfather visiting his cousins in Providence each New Year's Day. I accepted these anecdotes without question until it occurred to me to ask what Providence cousins they meant, as there were none that I knew of in my lifetime. No one in the family seemed to have the answer, yet they had always spoken with conviction of the existence of such individuals. After studying the city directories, I knew exactly which cousins my grandfather had called upon. My father recalled visiting the home of a policeman, an occupation that would have been likely to impress a young boy, and he vaguely remembered the presence of an elderly woman in the house. I know now it must have been Ernestine, who had lived to be eighty-eight; the city directories revealed that she had been living with her daughter and son-in-law, a policeman, on Arch Street. Here was my own father visiting an ancestor about whom I wanted to know so much once I had identified her photograph; all along he had not known that he had visited the home of the fascinating woman in the photo in his grandmother's album. Sometimes we envy our predecessors their experiences, moving in and out of the lives of family members of earlier generations in a way that we would never be able to share except in photographs.

Obituaries

Newspaper obituaries of ancestors can be particularly revealing in their inclusion of details, of which future generations probably have no knowledge, given by the family at the time. Obituaries give information about the deceased as well as data about other members of the family, facts which are sometimes even more important. You will find specifics about the life of the deceased, such as age, birthplace, and parents' names. Although information is generally quite precise regarding the deceased, I have seen instances in which nicknames were given for living family members rather than their complete names, giving you a bit more insight into the family. One of the most important aspects of an obituary is that it almost always lists remaining family members, helpful information if there is some question as to relatives left behind in the old country. Individuals acquainted with or related to the deceased had access to knowledge that our current generation does not have. Here you will have an opportunity to confirm information not commonly available elsewhere.

Obituaries are often surprisingly enlightening when we least expect them to be—sometimes revealing information that is contrary to what we already believe. Obituaries are also a source for unknown relatives; they reveal family nicknames, shed light on hyphenated names in cases where there has been a second marriage, and give a capsule summary of the life of the deceased—seventy years or so of living profiled in a concise nutshell. Obituaries give a quick overview of a life, permitting later generations to see what interests figured prominently in the lives of our ancestors. Occasionally, older obituaries are printed along with photographs of the deceased (a growing practice today) if the individual was a prominent citizen, was active politically, or was a Civil War veteran, for instance. More than simply a name and a face,

each individual ancestor takes on a personality when more is known about his or her life. Through sources such as obituaries, our ancestors become very real to us.

Most public libraries keep local newspapers from their earliest days to the present time on microfilm because it is neater, safer, and more practical to store. The microfilm viewer is simple to use by threading the film through a couple of designated slots; ask your librarian for assistance with the procedure the first time you use the unit. Modern microfilm machines are often equipped with a built-in photocopying feature so that you can make a copy of an item in an old newspaper without removing the reel, a feature you will want to take advantage of, especially if one of your ancestors' obituaries contains a photograph.

Cemetery Records

The final resting place of your ancestors is an appropriate place to begin your search for information about their lives. From the gravestone itself you will learn the names, birth dates, and dates of death for persons buried there. Always confirm this information with the cemetery records office; officials will be able to give you more details than the headstone will. Unfortunately, dates on gravestones have been carved incorrectly in some cases. The cemetery office will have the correct date of interment as well as other updated information regarding such things as perpetual care. Often when cemetery plots were purchased, they were intended as the resting place for large numbers of family members; one plot belonging to a long-ago generation of ancestors in my family contained eleven separate graves, although not all were filled. Some individuals are never actually buried in their intended spots because they married or moved to another part of the country before their death. In other instances family members are buried beneath

headstones on which their names are never recorded because they are the last living family member to pass on, and no one is left alive after them to arrange to have the stone engraved. Cemetery officials who work in the records office are very helpful about providing you with precise information as to who is buried in a given plot. They can also direct you to the exact location of the burial site if you are visiting a cemetery with which you are not familiar.

Information learned from cemetery visits can also be full of surprises, as is usually true of any genealogical search. A check with one cemetery office revealed to me information I expected to hear along with the completely unfamiliar name of someone buried in a family plot. The cemetery visit, ironically but conveniently, preceded a dinner engagement with an elderly great-uncle who was able to tell us that Benjamin Hunt had been the "boyfriend" of the woman with whom he was eventually buried, shedding light on a side of her life that we would never have known about with any degree of certainly without the memory of someone who had actually known both of the individuals in question. Another relationship had been established simply by talking to a relative.

On another visit, I set out to look for my great-grand-mother's grave, unmarked by choice according to her wishes because she did not want her second husband's name on her gravestone. My mother remembered the spot as being by a side fence in the cemetery. As we approached the site some fifty years later, even from a distance we saw flowers on the grave that we believed was never visited. On closer inspection, we found a stone identified simply as "Mother" and beneath it, "Mother of A. Barnes," reflecting my great-grandmother's surname. Office records revealed that her youngest son had erected the stone some years earlier in honor of his mother, apparently without notifying anyone in the family, and had

requested perpetual care which accounted for the flowers on the grave. Always make a point of inquiring within the cemetery office to see what information they can give you that you will not find on the stone.

If you are searching for the burial spot of an ancestor from a time when such information was not listed on the death certificate, start by calling cemeteries in the vicinity near where the ancestor lived. A great deal can be accomplished by telephone.

Newspapers

Your local newspaper and the newspaper for the town in which your ancestors lived can be of great help to you in your quest to identify family photographs. In addition to containing obituaries of ancestors, they also run marriage and birth notices, wedding announcements, and engagement photographs. A quick check in vital statistics records will give you the date a marriage took place; you can then go to the newspaper that corresponds geographically to the wedding around the appropriate date and search for a photo of the bride. Use the photocopying capacity of microfilm viewing units to make a copy of your relative's picture for your own collection.

The newspaper can assist you in other ways as well. Small local newspapers or weeklies are often very receptive to photography contests in which subscribers are asked to identify pictures of unknown individuals or buildings in their town from other generations. If you have unidentified photos taken in a particular community that are especially frustrating to identify, encourage the local newspaper in that area to sponsor such a contest. The printed photo may trigger a successful response from within the community and bring to your attention a reader who has the elusive answers you need.

Newspapers can be extremely useful if there are no city

directories at your disposal for help in identifying photos from an early period before directories were kept. By studying photographers' advertisements in old newspapers, you may be able to figure out when particular studios were in business in a given town. In this way you can verify not only studio addresses but also the years a studio produced photographs. Remember, too, that newspapers also retain their own library of photographs taken over the years. As a last resort, you might seek permission, at the convenience of the publication's staff, to view the archives of a paper that you suspect may have printed information about your ancestors.

Older newspapers especially will help you assemble a series of key landmarks with parallel dates that might match up with outdoor photos you hope to identify. Establishing the identity of local landmarks and architecture can provide you with a clearer direction in the identification process. Photographs that include landmarks under construction can sometimes be dated to within six months of the actual date the picture was taken. Be careful when dealing with newspapers which could contain photos printed from negatives that have been reversed; such errors happen occasionally and can steer you in the wrong direction when you are trying to construct an accurate picture of a particular location. Construction of a building may also be confused with renovations; buildings have even been moved on the same lot. Comparisons with similar photos will give you the true story behind the image.

Genealogical Societies and Social Clubs

Many areas of the country feature local ethnic social clubs that focus on various nationalities. In my area, the American-French Genealogical Society has such a club that maintains its own library of genealogical materials, open to the public one day a week with evening hours. Our local Irish Historical and Genealogical Society frequently offers evening lectures

and programs at the local library on a variety of aspects of Irish history. Why not approach such a group and suggest an evening devoted to old photographs?

Social clubs that are affiliated with various nationalities are one place where you are likely to find immigrants gathered. These individuals will be able to share with you their knowledge of the country from which they came and possibly direct you to a source of records overseas that can help you in your search.

Senior Centers

The value of community help should not be overlooked or underestimated as you attempt to identify old family photographs. The value of memory, particularly that of the elderly, has already been confirmed and is fervently appreciated by anyone who has spent any time attempting to identify old photographs. In many areas of the country, workers of a certain generation were all employed by the same mills or factories. This is especially true of smaller towns; the majority of employees performing unskilled labor would frequently be hired by a large company or business and spend their entire working life at the same plant, a lifestyle much unlike our modern tendency of moving on to better employment opportunities every few years.

Individuals who worked in one place for many years, whether it be a company or a community, can be a great asset to you in identifying snapshots of people from their own generation. They can certainly tell you all there is to know about the highlights of their youth and may perhaps remember some of the individuals in your photograph collection, if you know which relatives worked in a particular location or industry. Browsing through a photo album with someone old enough to remember its contents or recognize landmarks

from an earlier time can open up previously unimagined lines of inquiry and reveal new relationships to you.

As people age, the more it seems they love to reminisce about the "old days." Make a point to contact senior citizen organizations within communities where your ancestors lived and explain to the administrator in charge your intentions in calling upon the group the center represents. Always take a photograph album with you when visiting senior centers for the purpose of identifying photos and plan on spending time there so that your audience will not feel rushed. Seniors confined to nursing homes will enjoy sharing their time and stories with you.

Published Family Genealogies

Those passengers who came to America on the *Mayflower* were not alone in settling the New World. The initial colonists were quickly followed by a succession of early pioneers who played an important role in the development of individual communities as the colonies began to take shape. The lives of many of our country's earliest settlers have been described in detail and their lineage traced by surviving family concerned with recording the line of descent from the first colonists. Succeeding family members have been cataloged in bound genealogies that have been published for the reference and aid of all direct descendants.

Such publications contain a listing of all progeny, generation by generation, up to the date of publication, often to the early or middle decades of this century. These genealogies will give you the complete line of descent from our early American ancestors and often detail the lives and lineage of our own ancestors' forebears in England and other countries of origin back to, or even before, the sixteenth century. It is heartening to realize that access to the lives of our most ancient ancestors who never came to America is available to

Photographers' Records

Business records that have survived from early photography studios may be able to give you additional information on particular sittings and portraits. It was a normal nineteenth-century procedure to list negatives made in ledger books that also described the subject and listed the date photographs were taken. Photographers' account books, diaries, and letters may be able to supply information that can be matched with surviving photos. Each exposure was assigned a negative number, and portrait sittings always involved more than one view.

If in your collection of old photos you discover negatives as well, try having them developed today. Among some old photos, I located a negative that was obviously a rare picture of one of my great-grandmothers of whom I had precious few photographs, and I was always grateful to find more. Even though the black-and-white negative was probably from the late 1930s, when it was developed in the early 1980s, it still resulted in a clear photo that had not appeared elsewhere in my collection, and I was thrilled to have it. The individual who took the photo managed to chop off the top of my grandfather's head, an unfortunately common occurrence with tall subjects today as well, but I had plenty of photographs of my grandfather; more importantly, the picture of my petite great-grandmother standing beside her son was intact and certainly worth having developed.

To learn more about information contained in ledgers and account books, try to contact the remaining families of former photographers.

Reference Material

Your local library will prove a great asset to you in helping to broaden and clarify your image of the age in which your

Figure 4.4. Clues in this photo from the 1870s include the strong facial features, the uniform, and the printing on the border. Colmar and Mülhausen are in southern Germany.

ancestors lived. General reference books should not be overlooked in your search, for you will learn a great deal from them that will give you more background for a clearer picture of another time. Immerse yourself in the culture of the countries in which your ancestors were bred. Foreign dictionaries are useful in translating phrases on the back sides of foreign photos that may give clues as to what area of the old country an ancestor came from. Ascertaining the specific location in which an ancestor once lived can help you make the distinction between two sides of the family that came from the same country. If you know, for instance, that your mother's mother came from Hamburg, West Germany, while your mother's father came from Munich, you would be able to identify photos that had come to you from Germany simply by the location mentioned on the back of the photograph. Knowing that Munich is in the south of Germany while Hamburg is in the north can help you determine whether your photo is from your maternal grandmother's or maternal grandfather's side of the family and thus help you ascertain specifically which branch of the family it is from.

Much can be learned from documentary publications, compilations of nineteenth-century photographs, and pictorial histories and books that chronicle particular events such as the Chicago Fire, the San Francisco earthquake (with before and after pictures), or the California Gold Rush. Also helpful are lithographs and drawings from the nineteenth century whether they are originals or reproductions from books.

Other reference books you should consult for definitive styles of dress include fashion and costume books and texts on military uniforms for photos of soldiers, particularly those from other countries (see figure 4.4). A detailed knowledge of architecture, even hair and dress styles, will help you estimate the decade a photo was taken (see figure 3.4). Such knowledge is easy to absorb and will come to you naturally as you familiarize yourself with nineteenth-century styles through books and publications from either this century or the previous one. These will give you a better idea of the time frame with which you are dealing.

Other Photographs

One of the best sources you have to help you identify photos is the knowledge and background of other people. If you have graduation photos that you know are from a particular school, and you think that one may contain an ancestor you do not recognize or with whom you are not familiar, watch the local paper for notices of a class reunion for the year your photograph is from or a year close to it. You might also advertise or inquire locally for members of the class who may be able to help you in your search. Do not overlook records such as nursing school yearbooks, for they, too, contain photos of their graduates. Always watch for similar faces from one photo to the next; perhaps you will come upon one that is already identified for you either on the photo itself or through your own research.

Other good sources for finding photographs are flea markets, garage sales, furniture and antique dealers, auction houses, and estate sales. Do not forget to check museums as well as old bookstores for photos from an earlier age. Private businesses, societies, organizations, government agencies, and industries that deal with such products or services as oil, automobiles, airlines, banks, and department stores all maintain their own libraries of old photographs. Ancestors of yours connected in any way with a large firm would perhaps have appeared in a publication or photograph produced by such a company. Cultivate working relationships with professionals in these areas and let them know of your interest in old photographs. Rather than disposing of such items the next time the firm decides to clean out, they may keep you in mind to receive the photographic remnants that they might otherwise discard. Look carefully at organizations and places within the areas in which your ancestors lived. Any structure or business connected with the past in any way is a possible source of photos for you.

Specific Questions

Unique individual circumstances can most definitely arise when you are tracing your family history and attempting to identify old photographs. This section will address questions and issues that may surface during the process.

If you have no relatives to turn to for help:

For those who cannot get information from relatives, the place to turn is public records. By starting your search in birth, death, and marriage records, you will acquire the dates necessary to pursue a serious study of your photograph collection. Those dates form the foundation for the rest of your research. If you are looking for precise information about the lives of your ancestors, turn to city directories for

their addresses, occupations in which they were involved during their lifetimes, and specific years during which they moved from place to place. It is so much the better if they spent their lives in one state; it will make your research easier. For an even quicker overview of their lives, consult the local newspaper for their obituaries. You will already have the date of death from the death certificate.

If a public record seems to be missing:

There is always a reason for a record that is not where it should be. If a record you need is missing, try to think of a logical explanation and retrace your steps. Be sure you have the proper name and the correct town. Confirm all information before you panic. I had read in a family genealogy that my great-great-grandmother died in Providence, Rhode Island, yet could find no mention of her death in the historical society's index for that decade. From her tombstone, I knew that she had died in 1900 and was buried in Providence. I had traced her various residences through Providence city directories into the 1880s when she suddenly disappeared. It did not seem plausible that as an elderly woman she would have moved abruptly to another community. I finally discovered the truth while I was checking under her surname for others of that name who might have been born or married in Providence within the same time period: I found that she had remarried and hence had died under a different surname. When I consulted the index under her new name, I found the listing immediately and was able to trace the remainder of her life through Providence city directories up until her death in 1900. The possibility that she might have remarried in that time had never occurred to me. Whether she was actually buried with her first husband or her second I did not check as it did not pertain to the research at hand; but I learned a

lesson in dealing with women ancestors whose names can change and more easily become lost in public records.

If an ancestor's name does not appear among records where it should:

Again, be wary of nicknames when searching through public records which are always filed under a person's legal name. If you cannot find a particular document you need, maybe you are not using the individual's correct name. A great-great-aunt of mine who was familiarly called Aunt Mae or Aunt Peg by family members who knew her well during her lifetime turned out not to be Margaret at all but was actually Mary Ellen, a surprise revelation to relatives who were far less concerned with what her real name was than you as the family historian need to be. Though always known as Mae, another aunt had been christened Bertha Mae after her mother and never used her given name; few people ever knew her by her real name. Be careful of contradictory information that could account for records that seem to be among the missing but are actually filed under their proper names.

If you are not sure of an ancestor's parentage:

If you are uncertain whether Abby Smith is actually the daughter of John and Phoebe, check in the birth records for the correct time frame (look in the index first to confirm the date) and then check parents' names. The only problem that may arise is in a larger city hall where you are expected to produce the date initially before you can see the record in order for the clerk to find the requested document. This defeats the purpose of the searcher who needs the vital statistics record to learn such information in the first place (you cannot ask for a record by date when the date is precisely what you wish to learn).

Nor do you want to pay for a copy of a birth certificate that you do not need—if all you want to know is parents' names,

for instance—unless you want the certificate for some additional purpose. The great satisfaction of exploring vital statistics records is that they can rule out extraneous and incorrect possibilities, just as a blood test can determine one's paternity. Combing through vital statistics records or any published historical society material is always easier if your family name is not a common one (pity anyone tracing Abby Smith), but again, your genealogy by its very nature is hereditary; a surname is not something you choose but rather something that is chosen for you. Fortunately, for those seeking dates that can only be obtained through public records, there are a number of ways to obtain the same information without the aggravation of paying for a copy of a record concerning someone who might not turn out to be related at all.

*If you need information from a vital statistics record
but do not have the date:*

Some larger cities prefer, even insist, that you provide the names and dates of a birth, death, or marriage before they will send you a copy of the certificate. Often the reason you want to see such a record is to discover this information. Before you pay for a copy of a document you do not need, check elsewhere for the same information. Consult records in one of the many places of access where you can examine the information without actually having to order copies. Look through indexes or city directories at your state historical society or the largest one in the vicinity or check vital statistics indexes in the reference room of your local library. The indexes for birth, death, and marriage records will produce the same information and give you the names and dates you need without cost to you.

If you are tracing one of two individuals with identical names:

It is entirely possible in a large, close-knit family that two cousins could be given the same name, both Christian and surname, and spend their lives in the same town. Be careful while researching if you find two individuals by the same identical name, related or not, who could both marry women with the same first name. Birth records will not be of much help if both couples are about the same age and marry around the same time. Marriage records will help, but in an index of birth records, you will find listed the names and birth dates of children born to John and Mary Rogers, and you may not be sure to which couple the children actually belong. This can be a bewildering situation, to say the least. One man may have married Mary Stewart and the other Mary Allen, but that will be of no help to you after the marriage. Once the woman became Mary Rogers, her legal identity would have been absorbed into her husband's family name.

City directories and obituaries are the most direct way to find the answer you need without going to the trouble of sending for copies of birth certificates for children who may belong to the John Rogers who is not your direct ancestor. Begin by estimating approximately the date of death, perhaps around age seventy, check the death index for that decade, and try to locate the obituary. If he was not living in the area when he died, track down a newspaper for the community in which he did die and request a copy of the obituary from the local library.

If you are tracing a name on a photograph:

If you find an identified photo among your collection, consider yourself lucky first of all for such information is rarely provided for you. To discover the importance of this person within the family circle—initially you may not know whether he is a direct ancestor, related by marriage, or not a

relative at all—the best shortcut is to locate the obituary, if possible, for an overview of the person's life. Check city directories to see where the person lived, what his occupation was, and other clues to his life. The best strategy of all is to ask an elderly family member who might have known the individual in question. When this is not feasible, however, you must rely on the public records at hand.

If there are stepchildren in the family:

Be careful of ancestors who are not directly related to you who may have joined the family through a second marriage. Remarriages can lead to a great deal of confusion. A check in city directories can tell you the names of all household members of working age. At the very start of my search, I was confronted with two individuals named Louis and Ludwig living in the same household, although they possessed different surnames; after tracing the family through several years' worth of city directories, I noticed that when Louis was present, Ludwig was not. Nearly a month later, after considerable research, I learned that Louis and Ludwig were one and the same! Louis was merely the English translation of Ludwig; he used his stepfather's surname interchangeably with his own, a natural source of confusion to all but their circle of acquaintances who would have recognized him as part of one family living under one name. No distinction was made between stepchildren and natural children.

Remember that as well intentioned as they may be, relatives can unintentionally steer you in the wrong direction when it comes to remarriages in earlier generations. If you find yourself mired in confusion of this sort, check through your information carefully until you are able to figure out where the discrepancy originated. It will seem odd to you in retrospect that the truth did not dawn on you sooner, but it

is also a good lesson to take no one's word for granted when researching. Your own search can lead to all kinds of unusual circumstances of which you need to be aware.

Some Other Research Tips

One should not be surprised to find that discrepancies in public records happen easily and are common enough. Accurate record keeping on your part is essential as contradictions and spelling variations can complicate your search and hinder progress. Even information on gravestones can be incorrect; fortunately, cemetery offices contain complete records as to burial details. Record discrepancies you find so they will not confuse you or anyone else at a later date.

Family names are often repeated in successive generations, which is always a major source of confusion. In the eighteenth and early nineteenth centuries, because the infant mortality rate was so much higher than it is today, it was common for parents to name a second son after a first who had died, so that a listing of birth records might reveal two sons by the name of Samuel both born to Samuel and Lydia White. Repetition of names is common and indicates not only a popular custom of the day but the degree of affection within a family as well.

Though the German side of my family kept close ties with other immigrants from the old country, they learned English and made a number of subtle attempts to Americanize themselves and their family. No name was chosen arbitrarily; with all family members represented in the names given to children born into the next generation, names took on a special significance. The same names are reflected time and time again through ensuing generations so that three generations later eleven female descendants had been given

combinations of the three names of the original emigrating family, with the names Henrietta, Ernestine, or Augusta used as either a first or middle name or both. On the male side, my grandfather's wish that there should be a son to carry on the family name was rewarded with four generations of familiar names. His father, Ludwig August, had named him Ludwig Carl; his son was named Harold Carl whose son in turn became Karl Harold. Beware of the same-name trap that is always a source of confusion from generation to generation.

Look for particulars in your research. While it is difficult to find conclusive proof of age and identity of photos, you can make a close determination based on evaluations and conclusions you draw from your research in public records. There are always many surprises in store once you venture beyond the family legends into the realm of truth.

A point needs to be noted about the infrequent appearance of women in the record books. Women were the silent Victorian majority. The few records that were kept on them individually were birth, death, marriage, and children's births, and with that all was said and done. There is no clue in public records as to their thoughts or personalities. Only through their husbands did they achieve any significance on paper. Housewives were overlooked in city directories until well beyond the Victorian years, when they were finally mentioned as part of the household. Going through the record books, you might assume that there was always a wife in the house, but if the head of the household were a widower there would be no way of knowing from a nineteenth century city directory. Only if working outside the home were women listed in city directories and their presence acknowledged. It is easier to assemble a clear picture of the lives of male

ancestors than it is to compile an accurate picture of our female ancestors' lives.

Public records serve another purpose as well in that they possess the ability to jog our memory. Using the stimulation that the combination of facts and memory ignites, you will find yourself remembering aspects of your past once you see written prompters. Upon reading the name of the cemetery in my great-great-grandmother's newspaper obituary, I vividly recalled seeing the name on a neat, trim headstone on a small corner lot under a tree toward the center of the cemetery. Their plot was right beside the main road of the cemetery on which cars had to travel when driving out. Their last name was an unusual one, and I had been struck with the gravestone when I had first passed it because I knew that someone by that name was vaguely related, though the precise connection was unclear at the time. My great-great-grandmother was buried not five minutes from the town where I had grown up. I had never known that she was even in the country, and yet the family was all living together in America only a short distance from my own home. I was always told that my great-grandparents had come to America from the old country; I never thought that their parents might also have come with them. This revelation led to the discovery of another generation of ancestors' names because the information was available on their death certificates. The newspaper obituaries from 1908 and 1911 were brief announcements of death and did not contain elaborate details that extended to family life. The longer a family is in America, the more information will be available on those individuals.

The advantage of tracing your family's history through public records is that most records that you will need can all be found in one central location. Large historical societies often have their own libraries, city or town halls generally have vital statistics records for their community going back

many years, and public libraries have a wealth of free information as close at hand as the card catalog.

Vital statistics records, city directories, and town histories can be found in most historical society libraries, but these organizations generally have much more information to help those researching their family history. These institutions have a wealth of information to share with you, the researcher, even if you have to pay a nominal fee to use the facilities. Be sure that you write down what you learn accurately and note the source (you may prefer to photocopy some of your lengthier findings to reduce the chance of error) and organize your material before you go so that you do not waste time and energy on fruitless endeavors once you have reached your destination. Know in advance specifically what information you need. You will want to accomplish as much as you can from your day's work, though you should plan to spend more than a single day in your state or county's historical society library.

The historical society is an ideal source if you need specific details and want to learn as much as you possibly can in one place. Nearly all the information you need will be at your fingertips, certainly all the basics. In addition to the public records available, historical societies often have a large number of duplicate photographs that have come to them from estates as well as many that have been donated, some of which are already identified. Frequently, their collection will consist of rare materials, and they restrict the use of such documents to certain conditions. Larger historical societies often have indexes of vital statistics records or keep the information on microfilm because the originals are in ledger books that end up being stored in the basements and attics of city and town halls in various locations around the state instead of one central spot. The broken bindings and torn loose pages of these books are the result of continuous use over the years.

Such books are extremely fragile, often in a poor or crumbling condition. Large historical societies have a sizable staff that often includes manuscript and graphics curators as well as a number of reference librarians whose purpose is to guide you in your search. Many of these individuals are experts in historical photos who specialize in their own particular fields of interest—modes of transportation, for example. Submitting your photos to experts in relevant fields for verification can put you on the right path to identification.

Typical contents of a historical society's library might include census records; burial records, either indexed or listed by historical cemeteries; military service records listing those who fought in the Revolutionary or Civil Wars; genealogies of *Mayflower* passengers; collections of old photographs; published family histories, bound manuscripts regarding individual families; family association newsletters; special collections; publications of organizations such as the Daughters of the American Revolution and other historical groups and societies; scrapbook collections of obituaries; books on heraldry and coats of arms; general genealogies of surnames from other countries; biographical information; genealogical periodicals and manuscripts; town, county, and state histories; genealogical and biographical indexes to help you determine if you have the proper person while you conduct a search; reference material on Quakers; and various other source material.

Records vary greatly from state to state, and in order to know precisely what kind of information you can expect to find from your area's historical society, you need to spend a day just acquainting yourself with the library's contents. Some states retain vital records for the whole state up to a certain date when records became more plentiful, after which the records are individualized by specific towns up to the present. Not all cities and towns publish vital statistics records, in

which case you would have to visit or write the city hall that contains the record you need. Larger cities, however, generally do publish these records and offer indexes to help you locate the information you seek.

Most information that you will need to confirm dates given you by family members can be found within the city or town hall in the area where the ancestor in question was born, died, or married. Indexes to these records will facilitate your search and narrow the possibilities of error, and in some places you are still free to use the indexes and examine the original records. If you know for a fact that an ancestor's entire life was spent in a particular town, you should be able to trace the course of his life in town hall documents using his birth, death, and marriage records. I learned, for instance, that my great-grandfather and great-grandmother married on November 20, 1890, in the same town in which their five children were later born. By consulting the marriage records, I collected the names of their parents, giving me the identities of four more ancestors a generation further back than I had previously gone on that side. Such details add immeasurably to the sense of intimacy one feels for one's ancestors. I then checked in the birth records under the same name and found the full names and birth dates of my great-grandparents' five children. The next step was to check death records for such new information as might be found there, including cause of death and exact age. Entire lives can be pursued through these public records, which contain whole life stories.

Before you pay for any document or copy of a public record that you do not need, consider all options and investigate places that offer free information. Never underestimate the value of your local public library. The reference section provides a multitude of sources of free help and information in one location at no charge. Often large public libraries will carry vital statistics information and city directories for the

whole state. If not, individual smaller libraries in each town should. Local libraries are likely to have historical town material along with publications about your area written by local historical societies. Ask your reference librarian for help if you are not sure how to locate the information you need. Libraries as well as museums often feature historical exhibits from which you can learn a great deal about items of a historical nature. Also, consult the military texts, costume books, foreign dictionaries, maps, and reference books on the care of old photographs. You will find these helpful.

Your goal should always be to get as complete a picture as you can of your ancestors from the details you acquire over a period of time. As you make new discoveries, most faces in photos in your collection will gradually become accounted for. While you identify individuals, you can trace their lives in city directories simultaneously and really learn who they were. The process will enhance your knowledge of their lives and your appreciation of their photographs, giving you more of a sense of family identity. Through such a learning process details begin to fall into place and shadows take shape, adding definition to the lives of your ancestors.

Traditions will begin to make sense to you as well, and you will develop a fuller understanding of the reasons behind family customs. As I read about the traditional German Christmas tree, I knew why my grandfather's tree always had white candles when he was alive. It was a German tradition.

Bear in mind as well that photos, helpful as they are when used in comparison with other snapshots, can also be deceptive. The piercing eyes and coarse light hair of one male subject in a photo in my collection set the individual apart from the rest of the family as a handsome half brother. The three-quarter portrait view put part of his face in shadow, making him appear sterner than he actually was. I had traced the course of his life in city directories, a hunt that revealed

few unusual details. Later I scanned the newspaper page on microfilm for a small death notice and found instead a large headline, "Jakob Kohl Dead; Former Bartender," and beneath it another line, "Native of Germany, 77, was well known here before Dry Era." The lengthy article disclosed the fact that he had been a popular bartender at the Dresden, at the corner of Snow and Chapel, where he was well known to the patrons and where he "presided behind the bar for 35 years until the advent of Prohibition resulted in its closing."

Still, while his facial characteristics clearly marked him as a half brother, his own sister more closely resembled the other brother and sister in the family to whom she was a half sister! Appearances can be remarkably deceiving in photographs because of the static quality of their subjects. My great-grandmother, who stood no more than four feet nine inches tall, appears to be nearly six feet as she stands posed on a wall in front of her home in one picture that was taken at ground level looking upward.

Again, it takes a combination of sources to give such a complete picture. For years, Jakob Kohl had been listed in city directories as a clerk, which he probably was by day. If at that point I had known the value of an obituary, how much time I would have saved in my search, but how many joyous experiences in discovering lesser known facts would have been lost. Always take the time to investigate all channels to help create a vibrant picture of an ancestor's life.

It is important to realize that reliance on your own knowledge of history is as valid a source as any other. Knowing, for example, that the first gas lights were introduced in San Diego in 1881 and that horse cars appeared first in 1886 and cable cars in 1890 can help you in dating old photos. What you do not know you can learn in books. Never feel that solving the mystery of identification is beyond your

comprehension or realm of experience, for the process is a learning experience in itself.

Do not linger over a particular source of information if you are feeling frustrated. Instead, go elsewhere for the same information that might be more readily available in another place. There are certainly enough public sources to keep the search alive. Information you need can be found in one source if not in another. Retrace your steps if necessary to validate information you have collected, and follow your hunches. You will probably have plenty of occasion to feel that the truth is not available and that your search is a fruitless one; but by checking your connections further, you will usually find that roadblocks are often no more than temporary setbacks. Slowly or otherwise, you will gradually accumulate facts that will, step by step, reveal identities to you as you develop a sense of recognition and become increasingly familiar with the faces in the photographs.

5. RECOGNIZING TYPES OF PHOTOGRAPHS

In attempting to recognize different types of photographs, some understanding of photographic methods and processes is needed. With a little background, it is not difficult to be able to tell roughly how old a photo is by carefully examining it. In order to identify ancestral photographs, you will need to know approximately what period the photos are from. Assigning photographs to a particular time frame is a valid way of dating them and helps lead to eventual identification.

Knowing the chronological history of photography, or more specifically the history of photographic portraiture, is a valuable tool for identifying nineteenth-century photos. An accurate knowledge of the periods in which different processes were used to make photos is significant as many processes were used during only a short time segment of three or four years to twenty years. Burnished albumen prints, for example, were generally made between 1878 and 1890.[1] Daguerreotype and ambrotype cases and cardboard mounts can accurately define the age an item was made and offered for sale. By identifying the type of photo through close examination, one can determine approximately when it was made.

Until they were replaced by the photograph, miniature portraits, painted in watercolor on ivory and measuring no more than an inch and a half high, were extremely popular in the late eighteenth and early nineteenth centuries. Daguerreotypes pushed the expensive miniature portrait out of favor, taking the glamour from the wealthy to give to ordinary individuals. No longer something only the affluent could enjoy, photographs were affordable even to the middle class.[2]

As a result of this new realism in portraiture, the custom of retouching photographs also came into being in the nineteenth century, originating with photographers who were sensitive to their clients' vanity. Accustomed to portrait painters who portrayed individuals through the artist's interpretive eye that could redefine imperfections, some customers at first found the photograph with its element of raw truth offensive. As a pacifying gesture, both negatives and prints could be retouched.[3]

Depicting life in its stark reality, photographs provided evidence of concepts and customs that existed in such distant locations that they could not be viewed firsthand. People's knowledge of the far reaches of the world was limited until photography allowed them to experience travel vicariously. Photography helped to lessen fears about the western colonization of the nation as photographers were suddenly able to chronicle history as it happened before their eyes. Photos lent a familiarity to ideas that had previously seemed strange and gave faraway elements an immediacy in the lives of ordinary citizens. Through photography, society had its first glimpse of Indians; viewed in photos, they turned out to be not as savage as they were suspected to be.[4]

Instantly popular and enthusiastically received, photography has been a part of the American lifestyle since the early nineteenth century. The earliest surviving photo is a daguerreotype from 1840, though the first picture was actually taken

in 1839. The initial photographic process combined a nega-
tive and positive in a single image; thus the earliest
photographic images—daguerreotypes, ambrotypes, and tin-
types—were transferred directly onto the metal or glass plate
within the camera without the use of a negative. The sig-
nificance of these early likenesses lies in the fact that they were
uniquely one of a kind with no multiple prints available.

The first negatives that exist separate from photos are for
calotypes, another early photographic process, and those that
remain today are preserved in museums. The use of the
wet-plate collodion negative, beginning in 1851, produced
the print on paper with which we are familiar today. This glass
negative from the 1850s utilized a single image plate process
that resulted in easier production of multiple paper prints.
Liquid collodion, a coating of a chemical solution, required
that the sensitized plate be hurried into the camera for
exposure while still wet in what was a clumsy, unwieldy
process.[5] With the glass negative many paper prints could be
produced, the negative's large size accounting for the clarity
of the image of the print.

This method was used into the 1880s when it was replaced
by the dry-plate glass negative. Presensitized in the factory
before it arrived at the photographer's studio, the dry-plate
negative could be kept for long storage periods. The glass
negative and printing paper were placed as close together as
possible in the printing frame before the frame was exposed
to natural light for the time required to develop the print.[6]
The prints were then finished with gold toning, giving them
the warm sepia tones often associated with old photographs.
These prints, made on thin paper, were mounted on
cardboard backings for the protection of the print and for
easier handling. One common size, 4½ x 6½ inches, was
known as a cabinet card or cabinet photo (see figures 1.2, 1.3,
and 3.1). Many of these photographs are still in existence

today, in individual collections as well as in historical societies and in the hands of antique dealers.

Right from the start there was interest in adding color to photographs. It was applied originally by using hand dyes, pigments, or metal compounds. Daguerreotypes, ambrotypes, tintypes, paper prints, and lantern slides all had touches of color added to them. The first experiment related to the theory of color vision was performed in 1861 when a scene was photographed as a black and white image through three color filters in red, green, and blue. The first natural color process that was commercially successful was introduced in 1907 and used for nearly thirty years. This method was rapidly followed by other types. Currently, most color developed photographs today are made with dyes forming a color image that is created in the film during processing. Instant color prints such as Polaroid SX-70 prints use metallized dyes with excellent light fastness properties.[7]

In the 1880s, it was common for a tent to serve as a makeshift photo gallery, darkroom, and sales office all in one.[8] Studios were even set up in fields in frontier days, and photographers during the Civil War set up shop in the middle of battlefields. Shooting galleries consisted of mounted portrait cameras, posing chairs, and overhead reflecting screens. In the front sales parlor were framed examples of the photographers' finest work that clients could view while waiting for a sitting.[9]

In the late 1880s, continuous belts of film came into use when Kodak began to manufacture and sell roll film that could be used in small hand-held cameras. With the arrival of the twentieth century, nearly everyone owned a Brownie camera, and billions of photographs were gradually taken by average individuals (see figure 5.1). Photographers came to be less highly regarded as the distance closed between the amateur photographer and the photographic process. "You

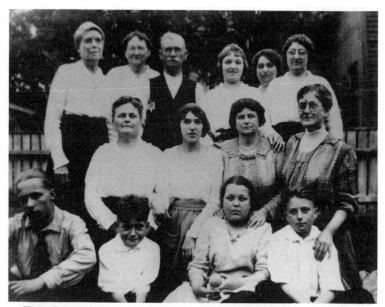

Figure 5.1. A casual family portrait taken around 1920. The author's great-great-grandfather (top row, third from left) died in 1923. Some of the same subjects also appear in figure 1.1. Multigenerational photos give a good indication of the differences in children's ages, making identification easier.

push the button, we do the rest," was Kodak's slogan then.[10] By the turn of the century, it was rare that a person had not had his picture taken at least once.

As one of the major applications of photography, portraits were generally produced through particular photographic methods. The major types and styles follow, some of which were more common than others. A general overview is presented here to acquaint and familiarize you with the various processes so that you will be able to recognize them when you come across them.

Daguerreotypes

Daguerreotypes were made from 1840 to 1860. Popular for mid-nineteenth-century portraits, the earliest surviving

daguerreotype is from 1840. They were an instant success, selling for about two dollars and requiring a portrait sitting in which the subject had to be immobile for twenty to forty seconds. One enterprising New York photographer entertained children while trying to photograph them with a toy bird inside the camera that would sing and occasionally peek out at them to attract their attention.[11] Outdoor scenes were scarce, though daguerreotypes eventually traveled around the world once their popularity was established, making their way into the Yucatan jungles and to Japan, leaving their mark in this country in photographs of America's western wilderness and mining camps.[12] They were sent by those who embarked on journeys during the California Gold Rush to families back home who anxiously awaited word from their loved ones.[13]

Daguerreotypes were not produced from a negative; the earliest photographic process combined a negative and positive in a single image. The daguerreotype image was an amalgam of mercury and silver on a silver-coated copper plate. It was the only photograph made on a sheet of highly polished silver-plated copper, made directly on the metal plate without a negative. The image on the plate can appear to be either negative or positive depending on the angle at which the light strikes its mirror-like surface. By tilting the plate and manipulating the angle, the image may be made to appear as a positive for easier viewing. The negative/positive appearance of the daguerreotype is a crucial key to its identification, more so than for any other type of photo. Early photographers were unaware of the dangers inherent in producing daguerreotypes; many of the first to use the process died a slow death from mercury poisoning after inhaling the toxic vapors that rose during the heating process.

Although the silver tarnishes and the surface scratches, the sheet of copper with its bond of silver is permanent. So delicate that even fingerprints can mar them, daguerreotypes

are easy to recognize by their physical appearance. They have a metallic silver surface, the silver-toned photos generally made before 1842 and the brown ones after 1841. Gold toning was added to them in France in 1840. Cheeks were often "rouged" with a touch of color added by hand once the photographic process was done. The daguerreotype frame almost always includes a die-cut ornamental embossed brass mat and clear cover glass. The mat, image, and glass were taped together and the taped edges covered with a narrow metal preserving frame. The entire assembly was then fitted into a compact hinged case that was included in the price. The inside lid was often padded with satin or velvet, frequently rose-colored, and sometimes contained the maker's name. The image itself can also be found loose without the mat and case as some were separated from their original containers over the years.

Daguerreotypes were made in a variety of standard sizes. The original camera produced a photograph that was 6½ x 8½ inches (called a full plate). Rare exterior views were usually this size, although portraits were often smaller. Other dimensions of daguerreotypes are as follows:

- ½ plate: 4¼ x 5½ inches
- ¼ plate: 3¼ x 4¼ inches
- ⅙ plate: 2¾ x 3¼ inches
- ⅑ plate: 2 x 2½ inches
- 1/16 plate: 1⅜ x 1⅝ inches[14]

Because old photographs do not always remain in their original cases, it is useful to understand methods of identifying particular photographic types based on the photo alone and also to know how to distinguish photos in frames or cases through dirty glass, a common state for old photos. The

daguerreotype image has a shiny, metallic quality and is the only very old style of photograph that lies on a true mirror surface; the image is seen as positive at only a few angles and only when the dark area is reflected in the daguerreotype's surface. It is seen as a negative image when the light area is reflected on its mirror surface.[15] A typical daguerreotype will appear bright and clear with fine detail. No other type of photograph matched these sparkling qualities.

Ambrotypes

Nearly all ambrotypes made were portraits. They were produced in the United States between 1854 and 1881, though they reached the height of popularity in 1856 and 1857. The ambrotype was made in the same standard sizes as the daguerreotype, and its case consisted of several layers as did the daguerreotype's.

Like the daguerreotype, the ambrotype was not produced from a negative; but unlike the daguerreotype's metallic surface, the ambrotype was a wet collodion negative made directly on glass. An ambrotype by definition is a glass negative that appears as a positive when viewed against a black background. The earliest ambrotype had a black velvet backing; later black paint, fabric, paper, or lacquered metal was used. The deterioration of this backing makes the ambrotype appear to be wearing out when in reality it is simply the backing that needs to be replaced for restored visibility. Its change of image is actually an illusion.

The ambrotype can be seen as a negative when the light hits it from a certain angle. Viewed through the cover glass, the image surface appears gray-green, unlike the highly polished mirror surface of the daguerreotype. The ambrotype has a nonreflective surface. Touches of color were often added to the finished image. Delicately tinted by hand, pink cheeks and gold jewelry added a spark of life to the static subject in the

camera's viewfinder. Colored clothing or drapery was often featured.

The image on glass never produced a great contrast range; its shadows were without detail, and the highlights were never a clear white. Standing upright on a white sheet of paper, the ambrotype will always reflect a positive image.

Tintypes

Widely produced from 1856 into the 1920s, tintypes were popular in part because of their durability. The fact that the backing was a thin sheet of black enameled iron eliminated the need for a glass cover; tintypes could be shipped or carried easily without the risk of shattering. For this reason, Civil War soldiers sent home many that were made by itinerant camp photographers.[16] A few daguerreotypes and ambrotypes even served as early political campaign buttons, but tintypes were more widely produced for such a purpose. Used by Abraham Lincoln, pictorial campaign buttons helped to make his face better known to voters.[17]

Tintypes were a direct positive photographic image upon a sensitized iron base, made of black, japanned sheet iron coated with collodion. The photographic surface was actually a piece of metal coated with emulsion, a silver or salt solution. They were inexpensive to make and more durable than anything available at the time. Tintypes were the last of the images fixed and viewed on a single surface requiring no separate print; they were not produced from a negative but were in essence their own negatives. They were also called ferrotypes or melainotypes, "ferro" from the Latin meaning iron and "melaino" from the Greek meaning black or dark.[18] The tintype was introduced later than the ambrotype but was popular for a much longer period. It was the only image along with the daguerreotype to be made directly on a metal plate without a negative.

The metal in a tintype is firm and appears to be painted black or dark brown on the reverse side of the image. The surface is varnished for protection and for better viewing. Highlights are dull and other tones muddy, and the image itself is dull gray like the ambrotype. After 1870, chocolate tinting was added.

Tintypes range in size from very small to fairly large. The smallest, ¾ x 1 inch, less than the size of a dime, was known as a tintype "gem," while the largest was about 8 x 10 inches, the size of a full plate (see figure 5.2). The most popular size was the small pocket or wallet-sized photo, sometimes found today in daguerreotype or ambrotype cases. The smaller plates had chipped corners and were intended to be inserted into cheap paper holders. Miniature albums were designed and sold to hold "thumbnail" tintype portraits.

Tintypes should never be flexed as the surface may crack at the bend where it tends to become brittle. Because of the consistency of the metal backing, they are frequently scratched and dented when found.

Pannotypes

Pannotypes, made between 1854 and 1860, were made of leather and oilcloth and are extremely rare today, most likely because leather and cloth tend to deteriorate with age. The soft leather was coated with light-sensitive chemicals and an image then printed on it. The process produced circular photos that were often placed in lockets worn on chains by women.

Calotypes

Calotypes were the first photographs taken with the present negative/positive system that allows multiple prints from a single negative. From a process invented by William Henry Fox Talbot, the photographs themselves (also called

Figure 5.2. When this full plate tintype was removed from its frame, the oval remained around the head and shoulders. The outline of the subject's wife's shoulder is discernible to his left in the original.

Talbotypes) can be recognized by their lack of detail. The vagueness of the image was due to coarse fibers in the papers used for the print and negative. Sheets of handmade drawing

or writing paper were dipped into a salt solution and wiped dry, so they were often known as "salted prints" or "salted paper." They were taken at such a slow speed that the first subjects were immobile. Calotypes were never popular because the use of the practice was restricted by a patent in 1841, and photographers refused to pay for the new method. They were first made in 1839; the process was improved in 1851, and from 1885 to 1888 they became popular for the last time. Little more than faint pale yellow images today, calotypes are both rare and valuable, possessing a soft quality without much detail. Chemical aids are used in restoring them in a process known as silver intensification.

Stereographs

Produced shortly after the Civil War, stereographs found today are often referred to as "3-D" cards. The 3 x 7 inch rectangular cardboard mounts featured two almost identical photos mounted side by side, intended to be seen through a stereoscopic viewer. Stereographs were widely issued originally in hand numbered sets and later in printed sets by publishing companies. It was rare to find a home that could afford them without at least one set of stereographs. Subjects included nature, news, historical structures, battlefields, art galleries around the world, portraits of royalty and distinguished individuals, and theatre personalities.

Lantern Slides

The popular forerunners of moving pictures, lantern slides were glass transparencies designed for viewing by projection. They measured 3¼ x 4 inches and were made in great quantities. The positive glass transparency, either black-and-white or hand-colored, was sandwiched between plates of thin glass, its four edges secured with black tape. Made in sets dealing with a single subject, they were kept in covered

wooden boxes with dividers that held each slide separately. Lantern slides were positive transparencies and should not be confused with glass negatives.

Albumen Prints

Albumen prints were introduced in 1855 and used in America from 1860 to 1890. The smooth paper was coated with albumen (egg whites) and sodium chloride (salt). The coating was then sensitized by a layer of silver nitrate which reacted with the salt to form light sensitive silver chloride. The photographer purchased the paper already coated with albumen and salt, a process that required millions of eggs in its day. The albumen gave a luster to prints made from this paper. In the making of a print, the albumen paper was placed in contact with the negative in the printing frame and exposed in the sunlight. In 1880 most photographers adopted the system of burnishing albumen prints, applying a glaze to the surface of the print and running it through a burnishing roller machine. This is a giveaway in trying to identify and date albumen prints made from 1879 to 1892.

Albumen prints were made in standard sizes and glued to cardboard mounts of corresponding dimensions. The sizes of the mounts and the dates they were introduced in the United States are as follows:

- Carte-de-visite: 4¼ x 2½ inches; 1859
- Cabinet: 4½ x 6½ inches; 1866
- Victoria: 3¼ x 5 inches; 1870
- Promenade: 4 x 7 inches; 1875
- Boudoir: 5¼ x 8½ inches; unknown
- Imperial: 6⅞ x 9⅞ inches; unknown
- Panel: 8¼ x 4 inches; unknown

- Stereo: approx. 3 x 7 inches (rounded corners); 1859

- "Artiste," "Cabinet," "Deluxe" Stereo: approx. 4½ x 7 inches or 5 x 7 inches; 1873.[19]

The wallet-sized carte-de-visite was extremely popular in its day and was intended for use with or in lieu of a calling card. While larger photographs decorated the walls of fashionable homes—some in large, deep oval or rectangular shadow box frames—entire albums of cartes-de-visite could be found on sitting room tables. Occasionally, they featured scenic views, but they most often were used for portraits.

Cabinet photos, the next size up, were also both popular and inexpensive, and many people purchased them. Generally, such portraits were formal views and were designed specifically to be placed in an album with fitted slots of identical dimensions (see figures 1.2, 1.3, and 3.1). Many such photos are still in existence today and are in surprisingly good condition mainly for two reasons. The firm backing can be credited with the survival of most of these photos that were loose over long periods of time, and those that were kept in albums for several decades received extra protection against damage from sunlight, fingers, and other hazards of constant handling and exposure.

The other variations were all made in the standard sizes listed and, like the carte-de-visite and cabinet photo, were mounted on a stiff cardboard backing to protect the thin paper print. These sizes are less commonly found today than the two sizes previously mentioned. Because their standard sizes differed from ours today (4 x 6 inches has given way to 5 x 7 inches, although 4 x 6 inches is regaining some of its popularity and holders are again being made for that size), Victorian photographs fit in frames common to their own age but generally do not fit into purchased modern frames.

Cardboard mounts were used for thin albumen prints both before and after the turn of the century. Often the mount, on the front or back, would contain identifying information about the photograph, a specific negative number, or a caption with a subject, location, and date. Unfortunately, this does not usually hold true for portrait mounts that were often embossed or printed with only the name and address of the photographer. Such information can generally be found on cabinet photo mounts as well as cartes-de-visite. This common practice was a popular and successful form of advertising for the photographer, just as it is today. The name and address can sometimes be that of the merchant who sold the photograph and not that of the photographer who took the picture, but this is the case only with scenic views and not with portraits that were taken at local studios.

Other Photographic Types

Many photographic processes were attempted successfully or otherwise in the nineteenth century, but only a few of these historic endeavors were used specifically for portraiture. Of the many processes that were tried, some were merely subtle variations of one another, and a handful were very obscure. Many turned out to be undesirable as they were found to be impermanent processes. A number of methods were tried briefly and experimentally as commercial ventures and quickly disappeared as they were unsuitable for practical application. In some cases, only a few have remained to prove their earlier existence. One such type of photography was the anthotype, made with the juices of flowers.

Questions of aesthetics arose in the photography world as photography attempted to rival art. Julia Margaret Cameron enchanted her customers in Victorian England with her whimsical and romantic portraits that combined oil paints over actual photographs. Nearly all methods used were tried

as portraits at one time or another, but the majority of portraits still in existence today will fall into the broader categories listed previously. Many of the experimental processes were popular with artistic photographers who were looking to validate the photograph's place in the art world. Some of the photographers who dabbled in unorthodox but creative practices were actually quite prolific but have been overlooked by history as the methods they used were, artistically, professional failures. Still, several of these processes are worth mentioning as they are recognizable by their unique styles, and should you come across one you will be familiar with it at least by description.

The platinum print or platinotype, made from 1880 into the 1930s, was notable for its beautiful silver gray tones. Popular with art photographers, the process was forced out of common practice by the rising cost of metals.

Cyanotypes were first made in 1842, and the process was revived in the 1870s, producing prints in a bright blue shade. Some portraits were done as a novelty, appealing to amateurs because the method used was not a complicated one.

Woodburytypes, popular from 1865 into the 1890s, involved a photomechanical process that resulted in a chocolate or violet-brown print with a subtle but distinct relief image on the print's surface. The vandyke or "brown print" process, first done in 1889, was never widely used because of questions about its permanence. The rich brown print featured fine shadow detail.

Gum bichromate prints, used from 1858 until the 1920s, were made from different colored pigments that produced a rainbow of colors although the resulting photo was generally done in a single color. A rare gum bichromate photo will feature two colors. A few portraits were done, but the exposure time was so long that it made lengthy portrait sittings

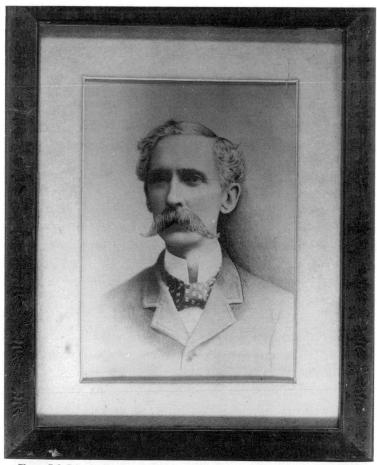

Figure 5.3. This mixed media portrait features a photo of a head with the shoulders and lapels sketched in pencil. The picture is oxidizing with age, making the hair and mustache seem to be lifting away from the face.

impractical. The process was used primarily for artistic photography.

A fairly common type of picture still found today is the mixed media print. This type of photo is difficult to date because the process has been used since the beginning of

photography. Mixed media prints often involved illustration as part of the actual photo (see figure 5.3). Some were hand colored while others were partially sketched; although the head might be a standard photograph, the coat collar and shoulders might be sketched, for instance. In such photographs, clothing styles are frequently the only clue as to age.[20]

Do not confuse a photograph produced from one of the many silver processes with the earlier daguerreotype. Silver prints, made several decades after daguerreotypes were produced, were often placed in frames with an embossed gold mat similar to that of the daguerreotype. You can tell a silver print by the silver-blue glare of shadowed areas that appear to be pasted on, almost as if they are separating from the rest of the photo. The silver that is oxidizing and seems to be lifting from the image is quite distinguishable from either the daguerreotype's positive/negative quality or the albumen print's even surface.

From the 1880s through the 1920s some fairly standard types of photos were taken. Many measured $3\frac{3}{8}$ x $5\frac{3}{8}$ inches and were printed on a postcard backing. As you group similar photographs together, you will see a pattern emerging as you find recognizable styles from different periods. These varying styles are often indicative of the age of a photograph.

Popular props for women photographed from the second decade of this century through the 1920s were a bouquet of roses and a white shoulder mantle (see figure 3.3). Watch also for public landmarks that can date candid photographs such as park statues or gazebos; in many communities there are desirable photogenic spots that are often used as backdrops (see figure 5.4). Roger Williams Park in Providence, Rhode Island, has a statue of a retriever that has been there for decades. Nearly all the children of my generation who lived there were photographed while seated on the dog's back at least once during their childhood, and the celebrated canine

Figure 5.4. This dog in Roger Williams Park, Providence, Rhode Island, with the author as a child astride, has been a favorite monument for picture taking for decades.

is still a favorite companion in photographs of children taken today.

Take clues also from the physical format of prints. Snapshots from the 1940s and 1950s, for instance, have a familiar wavy edge to them; borderless prints with rounded edges came into style in the 1970s. Do not judge by the condition or cracks in the photos; some of my oldest photos are in better condition than more recent ones.

Be wary of "old" photographs that are reproductions of the original. While the image itself may be old, copies made of old photos cannot always be accurately dated by their physical appearance because the substance of a modern print is different from the materials used in making the original. A

friend once showed me a copy of a photograph of her grandmother (who had led a "Bohemian lifestyle," she informed me) which had surfaced after her mother's death in the process of cleaning out. The photograph, taken around 1910, is a studio portrait of her grandmother as a beautiful young woman. Pictured from the hips up, she had obviously wanted the photo taken to display the abundant thick hair of which she must have been justly proud as she gazes upward, her arms outstretched. The dark flowing tresses, draped alluringly over her shoulders, stretch well below her waist and conceal her figure from the camera. It is clear, however, from the pose that she is wearing nothing but a skirt and thin drape about her upper arms—an extremely unusual and daring pose for the first decade of the twentieth century but one that reveals a degree of insight into her life. This is a prime example of the type of unexpected photo that can indeed turn up. Copies had been made so that each grandchild would have one; clear and sharp as the image was, without an approximate idea of the age of the subject, it would have been difficult to assign a date to the photo based on the copy alone.

In spite of a cultivated familiarity with various photographic styles, the strongest and most natural reaction many people have to their photographs is based on family resemblances that can make one completely forget the difference in generations. I found it curious to see two of my own relatives glance at a photo while going through a box of old photographs and, without hesitation, proclaim it to be their first cousin, then pause doubtfully as they began to comprehend that what they recognized was an uncanny family resemblance rather than a specific person or correct identity. The realization suddenly

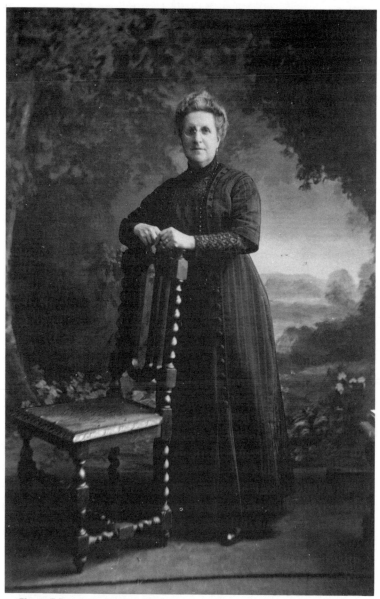

Figure 5.5. A dignified portrait of the author's great-grandmother, Elizabeth Crankshaw Barnes (1860–1930), taken in the second decade of this century on a postcard backing. The pastoral background is that of a studio in England.

dawned on them that the photo was too old to be that of their cousin and was from the previous generation. The photograph that they believed at first glance to be their cousin was actually their cousin's mother's cousin.

Photographs are as varied as the photographers who took them. They appeared in any shape or size, from hand-colored to black-and-white, mounted on thick or thin cardboard, had a shiny or dull surface, and were in familiar styles that reappeared from time to time within the world of experimental photography. Take particular care that you are not lured into the tempting trap of incorrectly identifying photos based on family resemblances that can be uncommonly strong, even over several generations. Such likenesses are potentially confusing to anyone trying to identify old photographs. Remember that photographs that are found together may not necessarily be from the same time period.

Recognizing different styles of photographs will aid you in dating them which in turn will help you to solve the riddle of identification (see figure 5.5). The age of a photo is an accurate hallmark of its date of origin. An objective, impartial knowledge of a photo's age protects the family history researcher against the illusory power of facial similarities that have the ability to cut across generations, reappearing unexpectedly like ghosts from the far distant past, trying to trick us into believing that time has stood as still as it does in photographs.

6. CARE AND RESTORATION OF PHOTOGRAPHS

Once you begin to acquire old photographs, identified or not, your next priority will be to ensure that they are restored if they need to be or that they are at least maintained under more prudent conditions than they were when you found them. By taking the appropriate storage or display measures, you will ensure that your photograph collection has a longer life expectancy than if it were to continue in a state of neglect.

You will want to see to the cleanliness of old photos before proceeding any further with them. Photographs that are found in a cellar, for instance, may need to be cleaned before they are even brought into the house, much less before they are identified. Some, hopefully those covered with glass, will have accumulated so many layers of dirt over decades in a dark and dingy cellar that the images are obscured to the point where the photo underneath cannot even be seen clearly. Do not be put off by layers of filth; you may find long lost treasure buried beneath the dirt and grime. Keep a soft clean dustcloth close at hand if you plan to spend an afternoon poking around in an attic or cellar along with perhaps wet paper towels to remove dirt clinging to the glass. Be careful, however, of broken glass covering an old and delicate

photograph inside; water is as dangerous to old photographs as broken glass is to fingers.

Once the heaviest layers of dirt have been carefully removed, while paying particular attention to the condition of the photograph, you will want to assemble other supplies for a more thorough cleaning. Photographs have survived in many and varied conditions of existence, from those that have been fairly well preserved to those that are almost unsalvageable; I hate to dismiss even a single old photo as completely worthless simply because it has fallen victim to the ravages of time, neglected for decades by others who placed no value on it until someone comes along to rescue it from further decline. As long as an image can be discerned, a photo is worth keeping for its value in helping to identify other photos.

Over the years the frames and coverings of photos can suffer physical damage while the prints within undergo chemical changes from age. Broken glass, chipped or gouged frames, scrapes, tears, water damage, stains, adhesions to glass, crumbling of the print or frame, and stains from the backing material are common consequences of years spent in a cellar or attic, particularly a damp cellar. The photos themselves may turn various shades of yellow and brown; develop purple splotches; become faded, scratched, or bent; stick together in the heat; have their edges eaten by insects; undergo irreversible changes from exposure to heat, cold, and humidity; and suffer irreparable damage from adhesives used in mounting and storing the photograph (see figure 6.1). These are the primary contributing factors that can lead to eventual decay.[1]

In addition to these common dangers, historical photos can suffer from serious deterioration over time simply due to human neglect. Do not be surprised to see other articles packed alongside old photographs; you will rarely find photographs in an old box without also finding dead bugs,

Figure 6.1. The only method of restoration for a torn print that has begun to lift from its cardboard mount is to make a copy of the original and fill in the missing area with a color filter to match the corner area.

dirt, and newspaper wrappings. Usually the only item of any value to you besides the photographs might be the newspaper, which could have a date that may or may not correspond to the date of the photo.

Be sure to record all information you find that could be of potential use to you at some future date. Scribblings on a box such as "Our old home," even if you are sure it is not your own family's home, might still be of value. Save any mention of such things as trip destinations or individual family names and include the names and dates of newspaper wrappings, even though you will most likely want to toss them out because of their probable state of decay. Any information saved may contribute to your eventual identification and dating of the photos inside the box. Additional information may come to light that will help you in the identification process, so be sure to preserve all clues along the way, whether they are relevant at the time or not.

Supplies you will want to have on hand for the cleaning process include well-laundered cotton cloths; clean, soft camel hair brushes (for removing dirt); cotton swabs; single-edge razor blades; bottles of liquid film cleaner (available from photo supply stores); and a pair of inexpensive disposable cotton gloves for handling photographs to keep finger marks off delicate prints. Hands, no matter how well they are washed, contain body oils, acids, lotions, and bacteria that should be kept from photos. Dirt and grime from old photos can easily be transferred from the surface of one to the surface of another.[2]

Tissues, besides leaving bits of lint on photographs, can also scratch even though they are as light as they are; cotton swabs and clean dry cloths are better. You may also want to have an 8 x 10 inch light box for viewing slides and negatives. A good clean artist's eraser will come in handy for lifting dirt from photos that have a dull surface. Stray marks on albumen

prints can often be carefully erased as long as you use the eraser lightly; many marks will lift right off with very slight pressure. Clean erasers are ideal for lifting stray marks, loose dirt, or smudges left from fingerprints; just be careful not to rub them in deeper or to leave a blemish on the surface.

General precautions to remember while cleaning photographs include the physical handling of the photo itself. Do not lay pictures face down on surfaces where they may get scratched; instead, lay them on a smooth clean surface such as glass. Try and keep the surface free from dust. Never write on an envelope with a photo or negative inside, as the pressure of the writing instrument can permanently mar the image on the print. Good ventilation as well as caution is needed when any type of cleaning solvents are used.

One of the most common problems with old photographs is that they tend to curl after a number of years in less than ideal conditions. After 1890, this happened often to the gelatin emulsion type of photo. Albumen prints that are removed from their mountings will curl as well. Mild curling can be reversed and corrected by pressing the affected print for two to three days beneath weights (intended for this purpose). The print should be laid flat and evenly between sheets of acid free paper during the process.[3]

More serious curling of old prints must be rectified by humidifying the print first. After existing for years without moisture, the fibers within the paper become brittle and tend to crack more easily, and therefore the print is more susceptible to greater damage while being straightened out. To prepare a print for straightening, sponge the back slightly with an absorbent cotton pad slightly moistened with water. Special photographic blotters can be purchased to protect the print while flattening it under weights or in a press designed for straightening photos. Be careful not to moisten the emulsion side of gelatin prints as this will cause them to stick to

the blotter. If in doubt, consult a reputable photo supply store or a photographer who deals with historical photographs on a regular basis.

Examine any photo carefully as soon as you find it before you try to remove it from its frame. First assess its condition and then decide what you intend to do with the frame, whether to keep it or toss it out. At some point, you may want to remove an old print from its frame because while the print is worth saving, the frame may be too far gone to be salvageable.

Special precautions must be observed with photographs that were designed specifically for insertion into unusual frames such as the convex variety. Some photos were pressed into odd shapes, even rounded like the glass that covered them and not flat as prints ordinarily are. Such photos cannot be vacuum-sucked onto the wall as is the customary procedure when making a copy negative because of the danger of explosion. The convex glass in such frames must be treated with caution as well; remember that this type of frame is indeed an antique and can only be replaced today with one like it because it is so rare. Take special care not to break the glass if you intend to use it again with the same photograph. A specialist in historical photography should be selected for the delicate work involved in restoring and copying a photo of this kind.

Whether you are dealing with a frame made of wood, metal, or gesso and gilt, you will be handling an extremely fragile physical object that has very possibly endured years of neglect; therefore, all frames require careful and painstaking treatment. A few instruments can help you take frames apart safely with as little damage as possible to the contents of the frame as well as to yourself. You may want to keep handy a table knife with a clean, dull blade (they are useful for leverage in slipping into narrow openings); a pair of pliers for

removing rusty old nails; a rubber spatula for lifting the print, mat, and glass away from its frame; a small hammer for knocking the frame apart; masking tape for holding broken glass in place so as not to cut yourself; a clean sponge to soak up moisture; and a small brush for lifting dirt from the print and removing mold and insect remains.[4] Do not be squeamish; the results of your labors will be well worth the effort!

You will generally find a variety of backing items used to hold the print in place, many of which can be disposed of instantly. Use tape on the glass if it is broken before you open the frame and dispose of the fragments cautiously afterward. The hanging attachments on the backs of frames, such as the wire and screw eyes, should be thrown away because they are of little value in helping to determine age and can easily be replaced; additionally, after years in a cellar or attic their dependability in hanging a print safely is questionable.

Use pliers to pull out the brads or nails on the backing boards. There is no practical reason to save the brown paper dust cover that seals the back of most old photographs. Check first to see if the backing, glass, and mat can be removed as one unit. Once the backing has come off safely, you can concentrate on getting the print out. Be particularly careful with the mat which can easily adhere to the thin paper print. The print could be joined to the mat either by being stuck directly to the backing with random spots of glue, joined to the back of the window mat with tape or with a continuous trail of glue around the edges, or not directly attached to the mat at all.

If the mat is soiled, stained, or decayed, your next step will be to lift the mat away from the fragile print by inserting a slender knife blade between the glue and the paper and gently working it loose. Do not force the knife as you run the risk of tearing the print by applying excessive force. This step

requires a steady and patient hand; it is not a procedure that can be rushed. If you are uncomfortable with proceeding any further with the removal process, consult a member of your local historical society who is experienced in the procedure. You can make the connection through your local public library or confer with a photographer who specializes in historic preservation. Occasionally, you will find a mat still in good condition. Often photographs were framed without mats with the border around the edge of the photo serving as a mat. For truly effective restoration, all old matting should come off as it is of no value and often detracts from the beauty of the photo itself.

You may come across larger photographs that were never framed at all, but instead were stretched across or mounted on heavy backing board or wooden supports. I discovered such a photo in my grandfather's cellar, measuring 16 x 19¾ inches, that was a copy of an albumen print cabinet photo I had found in a family album. The photograph was of his oldest sister, born in March 1892, the first child in the family. The larger of the two was a hand colored print. While the cabinet photo had been protected for nearly seven decades in an album, the larger photograph had probably been on display much of the time and then stored afterward; it had been in a damp cellar for at least twenty-five years.

When I found the larger portrait, it was beyond easy reach, perched precariously atop a mound of boxes and furniture amid the typical clutter of an often-used basement. Cobwebs and dirt hung about the edges of the photograph, which had sustained a good degree of water damage from sitting beneath a window. Water stains had trickled down in rivulets, forming a halo around the baby's head, yet leaving the face in remarkably good shape considering the treatment the photo had received.

In addition to the visible brown water stains, a sizable

amount of dirt had accumulated inside the back of the picture where two wooden boards had been nailed over the inside frame to protect it. The paper print had been mounted and sealed over a fabric lining similar to muslin that had been stretched over the supporting mount board beneath, with the wooden backing nailed over this inside frame. With this type of backing, stains can form on the back of the print's mount board from resins exuded by knots in the pine backing. Fortunately, this was not the case with the portrait I had found; I simply had to remove the wood back to clean the inside where dirt had seeped through the opening.

Wooden backings such as this can sometimes crack after years of alternate dryness and dampness. The primary kind of deterioration with my photo was water stains which, while irreversible, at least did not cause the fragile paper to buckle. I learned an unforgettable lesson through the care of this portrait which was one of the first I ever came across; it had survived twenty-five years in a cellar only to have its unbroken surface nearly pierced by a set of keys that were accidentally dropped on it while it was laid flat on a bed. Never, under any circumstances, place such a delicate print, either protected by glass or unprotected as this one was, on a bed or other flat surface unattended for any length of time; it can just as easily be jumped on by a cat or dog or suffer any one of a number of catastrophic events that can ruin it completely.

The next test this same portrait had to survive was that of extreme humidity followed by a summer storm. Open windows, even when a portrait is not close enough to get rained upon directly, can still let in too much humidity for a delicate old print to withstand. It was not long before I noticed the effects of the heavy dampness upon the print's lightweight surface caused only by the presence of humidity in the room. Take special care with old photographs, which often cannot

endure casual or unmindful exposure to our modern environment without precautions and forethought to their preservation.

There is a major difference between cleaning and restoration, however. When it comes to restoring older photographs such as daguerreotypes, ambrotypes, and tintypes, it is a job perhaps best left to a technician or someone experienced in the field of historical photographs. Using modern techniques, today's photographers can achieve amazing results when restoring old photos. A variety of techniques are readily available that can improve the appearance of old photos considerably.

Making a copy of an original is often desirable as the copy is a sturdy, exact, and inexpensive duplicate of an old and fragile print (see figure 6.1). Optical tricks can be used not only to minimize but also to eliminate damage. Stains can be made to vanish by copying through color filters attached to the camera lens, which make the spot disappear. By using a yellow filter, for instance, the camera used for copying sees the image before it in a yellow light so that the stain registers the same as the other bright areas in the picture. If the yellow stain appears in a dark area of a print, then a filter in blue, the complement of yellow, is placed over the lens. In this way the yellow light is blocked and the stain registers as dark as the area of the image around it.

Scratches on negatives can even be made to appear invisible. Microscope immersion oil is used to fill in scratches to match the surrounding area. When reflections on the surface of old prints produce bright spots, as buckled or dented tintypes can, polarizing screens are put over the light source to decrease the glare. In old prints with minimal damage, watercolors or inks can be used to patch up barely noticeable areas by applying tiny dots of paint. While it is sometimes better to have a modern duplicate of a frail and

badly damaged old print, the image in the copy does not always do justice to the original; the very antiquity of originals has an appealing quality that cannot be captured through modern methods of photography. Yet such tricks performed with a modern camera can produce seemingly magical results.[5]

Tintypes can be satisfactorily cleaned with items found in any photo supply store. For a general cleaning, you can use a cotton swab and professional photographic cleaning solution. Do not apply even a tissue to a tintype's surface as it will leave light but noticeable streaks. To remove dust that has collected during storage in a dusty place, use a soft, clean cloth such as an old undershirt or jersey material. Never bend a tintype as it may crack. Not only does the image deteriorate, but the metal backing dents easily as well.

As tintypes seem to darken, the negative image actually grows darker as the nearly black base begins to show through the fading image. The only way to restore a badly damaged tintype is to copy it photographically. Its shiny surface requires the use of polarizers and other light controlling devices that make scratches and blemishes disappear. For this procedure, you should consult a photographer who specializes in historical photographs. Your local historical society can put you in touch with a qualified technician.[6]

Often, ambrotypes can be restored by replacing the worn backing with a new acid-free piece of black fabric or paper. Ambrotype images begin to vanish when the backing wears out. The simple process of replacing the backing frequently restores the image to its original clarity.[7]

Daguerreotypes can be more involved to restore. As with an ambrotype, the layers must be individually separated—the cover glass, brass mat, image, frame, and case—before work can begin on the daguerreotype image. The photo itself is so delicate that even fingerprints can mar its surface. If you do

not trust your own ability or inexperience in working with chemicals from a photo or chemical supply store, you may prefer to leave the job to a professional. Thiourea is currently the recommended cleaning agent for daguerreotypes. For years, a solution of potassium cyanide, a dangerous poison, was used in bathing daguerreotypes but was found to remove the image as well as the tarnish. Thiourea will also remove the tarnish that forms even after a cleaning in today's sulfur–polluted air.[8]

Rather than attempt any procedure or allow anyone else to experiment with your originals, always have copies made before you use any type of chemicals in restoring old photographs. Chemical restoration can be both tricky and complicated even for a professional because there is no way to predict accurately how historical photographic processes will react with modern restoration techniques and materials.

Unfortunately, photographs do not have an infinite life expectancy, no matter how diligently we try to preserve them. After about seventy-five years photos begin to show signs of deterioration, both from internal processes and from physical influences. All photographs are eventually affected by temperature and humidity, atmospheric pollutants, residual chemicals and flaws in the original photographic process that cannot be corrected today, harmful fumes and vapors from a wide variety of common household substances, light, fungi, and careless handling. These effects are usually cumulative and often cannot be reversed, but you can at least try to keep the photos from worsening with better protection.

Photographs undergo multiple changes over a period of time because of their very essence and because of the individual methods originally used to bring them into existence, just as metallic silver tends to oxidize with age and the gelatin in the coating of paper used for some prints begins to suffer the effects of time and exposure to vastly different

atmospheric conditions from the time they were made. All photographic processes that were once used were new at one time, and all were experimental and therefore constantly undergoing the process of refinement. Over the course of time, many imperfections were eliminated from common photographic processes through trial and error.

Even in modern snapshots colors begin to change after a number of years. For this reason, photos should never be left in direct sunlight for long periods; such careless placement will shorten the life of a color photograph considerably. In the span of five years, I saw the image in a graduation portrait crack and fade to the bluish tint of the background simply from exposure to bright sunlight day after day; even the flesh tones, red blouse, and brown hair of the subject had faded considerably.

Appropriate storage steps should be taken for photographs that you do not intend to keep on display. Photos should always be stored flat if they are not already in albums that will hold them stationary. Most importantly, they must be stored in a location that is protected against heat, cold, sunlight, and humidity, particularly if they are put away in a spot where you cannot immediately notice visible indications of damage.

Both photos and negatives can be effectively protected in envelopes or plastic sleeves designed for storage purposes. Negatives should be kept in separate, individual envelopes so that they will not stick together. Original prints should be filed in individual protective transparent plastic (poly-propylene) sleeves or acid–free envelopes, folders, or boxes. They should never be exposed, even while in a file cabinet, to paint fumes or cleaning supplies that might be nearby. By protecting prints and negatives in this careful fashion, you will also be protecting them from dust particles that can penetrate the delicate, aging photographic surfaces. Archival storage boxes with leaves of acid-free paper and other low

acid or acid-free products are readily available from photographic supply houses. Many of these products can be ordered by mail.[9]

Photographs already in old albums should remain intact if for no other reason than that they represent a unified body of images, assembled by the individual who put them there in the first place. The order of photos within may have a certain significance in terms of identification which should be given consideration and studied as a potentially valuable clue.

The drawback of old-time photograph albums is that during the manufacturing process little consideration was given to removal of the photographs at a later date. While you will find albums with photos held in place by corners glued down that fit over the edges of the photographs, you will probably find just as many albums with photos glued right to the pages. Many of these albums are the large horizontal variety containing pages that are the consistency of black construction paper. After a number of years, glue will also contribute to the further deterioration of photographs.

Certainly it is desirable to remove photos from this type of album for further investigation. It is even possible, if names have not been written in white ink beneath the photographs, that they may be found on the backs of photos that are glued to the page. Definite care should be taken in the removal of old photographs so as not to tear them. Depending upon how well they are affixed to the album page, their removal may require the advice of a professional. You will probably wish to remount the photos after careful inspection of the reverse sides, but an experienced technician can tell you how to remove them with minimal risk of damage.

Such albums were used extensively through the 1930s and 1940s. The earlier Victorian-music-box-type photograph albums offered a more simple and effective removal of

photos. These albums, many of which were made in Switzer-
land, achieved their greatest popularity between 1860 and
1900 and featured a tuned steel cylinder that told the music
box what melody to play. Cabinet photos can be removed
from their slots in Victorian albums for examination pur-
poses with a letter opener. By sliding a letter opener or blunt
kitchen knife underneath them, you can slide them safely out
of their slots. Be sure to replace photos immediately after you
are done inspecting them so that they are never left in
unprotected areas where they can fall victim to accidents that
are the result of carelessness or neglect.

If you decide that the best home for your loose photographs
is in an album in an arrangement of your own design, you will
need an album appropriate for the cause.

The casual treatment and frequent handling of albums have
made the crumbling photo albums of the 1940s and 1950s
obsolete and have relegated them to the past where they
belong. Modern photograph albums offer more effective
protection of the prints within, are easy to use, and come in
a variety of price ranges. One of the most popular of the
modern albums is the magnetic kind with lift-up pages that
seal around the photos with adhesive that grips the clear
plastic overlay. Such permanently sticky pages, however, can
damage the backs of any prints, especially those that are
fragile; after a period of time the photos cannot be easily
removed because of the adhesive on the surface of the pages.
Even if you have no intention of removing the photos at a
later date, such albums may still cause permanent damage to
the mounted photos as they tend to age rapidly and the glue
can seep through to mar the finish of the prints.

In other types of modern albums, photos can slide into
plastic slots for display while pockets near the inner edge of
the album hold the corresponding negatives, an ideal
arrangement if you ever want to have copies made of the

photos within. For compact viewing and storage, a loose-leaf notebook style album has open-ended holders for prints that store two pictures back to back and flips up to reveal both sides.

If you have photographs that you wish to frame and display, hanging them in your home or arranging a tabletop display is another option to preserving them in albums, one which makes them more accessible and able to be appreciated for the treasures they are. However, a photo in normal daylight deteriorates faster than a photo in an album. A wide assortment of frames in various sizes is readily available today. Again, your choice of frame should be dictated by the concept of protection for your historical photographs. Always be sure to provide a glass front with any frame to keep dust from the print inside. A special glass is available that screens ultraviolet rays in normal daylight. When remounting photographs, old or new, always specify acid-free matting if you are having them framed professionally.

You may prefer to make your own wooden or textile frames if you are handy at woodworking or sewing or you may want to have your photographs custom framed; standard sizes today are different from what they were a century ago. In creating your own, you may wish to give a frame a Victorian appearance using fabric and lace. Many current craft magazines carry patterns for homemade frames. Wood frames should be varnished so wood does not stain the photo.

Encapsulating is a superior option for ensuring the permanence of photographs. Unlike lamination, which is a permanent process,[10] encapsulating seals the edges of two sheets of mylar plastic around the photo.

For old and valuable photos, a frame with a glass cover from which the picture can be removed is the most appropriate receptacle for display purposes. In all cases, both old and new photographs, whether color or black-and-white, should be kept out of direct sunlight.

Photos that have withstood the ravages of time require special protection from modern hazards. Hanging old photographs near a kitchen or bathroom, where strong odors or chemical solvents can travel in the air, may cause invisible damage that might go unnoticed until it is too late to correct. The safe and practical solution currently recommended by specialists in historic photography is to store original photos and display copies of them.

As your visual window into the past opens wider with new discoveries of old photographs, you will want to give yourself the clearest possible view of the ancestors within. Begin now to preserve for the future; time is precious, and it will not always be your ally as you undertake the salvation of old photographs. Your genealogical heritage is a unique, individual inheritance from the collection of varied and individual characters we know our ancestors to be. The legacy that they have bestowed upon you is one you will want to protect by taking appropriate steps now to preserve their photographs.

7. HOW TO LOCATE FAMILY PHOTOGRAPHS

The thrill and challenge of finding and identifying photographs of your family from former generations is matched only by locating more. Unfortunately, often the well runs dry long before the enthusiasm does.

In order to replenish your supply of photos continually, you must use your imagination to bolster your attempts to produce more photographs. For those who have exhausted their store of photos by contacting all possible relatives and who fear they will never find another picture in need of identification, take heart; there is no room for despair when playing genealogical detective. Nearly all individuals of our grandparents' day who had a camera also had an album. Remember that where there is one photo, there are probably more. You will be rewarded for your patience and persistence with additional photographs that come from unexpected sources. Cameras in the hands of amateurs and family photographers captured an entire range of human emotions and activities never recorded by studio photographers. Birthdays, outings, automobile trips, special occasions, once-in-a-lifetime events, beach parties, and picnics all found a permanence through the camera of the novice photographer (see figure 5.1).

Long after I believed that I would probably never find any more photos of my ancestors, they have continued to turn up. Relatives have located them in unexpected places, and having no use for them and unable to identify them as anyone of significance, they have sent them to me. A relative may pass away and an old friend will appear with a photo taken decades earlier that will be of interest to someone in the family. If you have been publicizing your interest in family photos, snapshots along with other relics will naturally be directed to you. New discoveries are always being made in the form of a large envelope or box found in someone's attic or cellar. If you are lucky, it might contain rare photos.

In the meantime, you need not wait for discoveries to be made or for opportunities to come to you. You can make your own opportunities by actively seeking out places where photos are likely to be hiding. Diaries, personal family papers, old letters or envelopes, the pages of old books, and unsorted collections in boxes from an attic or cellar are some of the best starting points. Do not overlook old passports, driver's licenses, or other forms of photo identification. Old houses once belonging to those of earlier generations that are still owned by someone in the family are one of your most significant resources.

If you have access to a home that has been in your family for many years, you could strike gold when hunting for old photos. My search was made easier by the fact that I was able to explore freely the house originally owned by my great-great-grandparents, a home that had never left the hands of their descendants through the next three generations. Check with relatives who currently live in the homes of your ancestors. Perhaps a modern-day cousin of yours has old photos in the cellar of which he is unaware. If you have cousins who now live in houses that once belonged to grandparents you have in common, it is very likely that old photographs could

still be stored somewhere in the house. Keep in mind that Victorian music box albums are also repositories for photos, even though they may appear strictly ornamental when you first discover them.

Do not be hesitant or reluctant to ask even distant relatives for help. You are, after all, a member of their own extended family, and old photographs may not be as important to someone else as they are to you. Even if they choose to keep the photos they already have, they would not be likely to object to your making copies of them. Photograph collections that belong to others in the family are your most immediate source for obtaining more photos for your own collection.

Family Bibles are also a wonderful storehouse of clippings and other memorabilia that might otherwise have been destroyed over the years. Newspaper items and personal or religious articles offer insightful revelations into the lives of our predecessors. Go through the pages slowly and carefully so that you do not miss any small item or tear the delicate paper. In the course of my search, I managed to locate small Bibles for each direct female ancestor in the four previous generations along with a large Bible that had once been displayed in my great-great-grandparents' parlor.

Tucked inside the pages of that Bible I found, along with an assortment of pressed flowers, a faded clipping from a newspaper of an earlier day that described a seventy-first birthday party held for my great-grandmother. I knew from vital statistics records that she had turned seventy-one the year after her youngest son had died, and I assumed this party had been arranged for her as a loving tribute from her remaining children who saw the occasion as an excuse to express their affection by surrounding her with family. The clipping had come from the society pages of the local newspaper, which were somewhat more detailed and informative in the 1930s than they are today. The article described the decorations and

color scheme and listed names of guests in attendance, revealing the names of her closest friends.

In the same Bible, I found a business card proclaiming my grandmother president of the Daughters of Union Veterans of the Civil War. While I knew that she and her sisters had been active in the patriotic association, I was never able to ask her personally about her involvement because she died before I was born. The rest of the family neglected to mention that she had been president at one time as the knowledge had by then receded into distant memory; the only way I knew was through the discovery of that card. The organization itself had begun to die out as admission into the society was limited to daughters and granddaughters of Civil War veterans, and their deaths heralded the end of their group. Yet the card remained as proof of my grandmother's interest in the society. Many informative items such as these are to be found in family Bibles.

Most Bibles also contain a section for birth, death, and marriage records, usually on pages separating the Old Testament from the New. Check the listings to see if any names and dates have been added or possibly a picture tucked inside. Note carefully the style of penmanship and quality of the ink; the data recorded could be less than accurate if all information given is in the same handwriting or if the color of the ink is the same for all entries, as if possibly the dates were all recorded at the same time. Identical handwriting and ink color are indications that the information might not have been recorded immediately after the event took place and could therefore be incorrect.

Always consider relatives who live out of state in your search. Ask within the family for their addresses first. If family members are unable to provide them, perhaps other relatives with whom you correspond by mail will have their addresses. If you cannot obtain a complete address but have only a city

and state, try writing the public library or historical society library nearest the location. You might tell them of your interest in making contact with your long-lost relative and even enclose a brief introductory letter to be forwarded to your (quite literally) distant relative. Always be polite and patient in all communications. Offer to pay for all postage charges as well as copies of photographs.

You might wish to enclose a stamped envelope with your relative's name that the library personnel can address and send to the intended recipient. Library personnel may not be authorized or feel comfortable with releasing the address of a local citizen to a complete stranger, but they would probably be willing to assist you in your endeavor by forwarding your letter and leaving it up to the recipient to respond. Unless the name is an extremely common one, library staff should have little trouble locating it in a current city directory or telephone directory.

My cousin in England who lost touch with relatives who had moved to Australia and hoped to reestablish communication with them used a similar method of locating them; she contacted the police in the Australian township where the family was reported to be living still and enclosed a letter to be forwarded to the branch of our family living "down under." The police were most cooperative in helping to reunite her with family members by mail. She has since visited these relatives. It might be advisable to point out that her search was conducted nearly twenty years ago. Still, such a direct strategy may be well worth a try for those who have exhausted all other options. Sometimes desperation creates its own resources.

There are ways to discover addresses of relatives out of state with whom your family has lost touch without hiring the services of a private detective to track them down. If the family lived in your area once, but remaining relatives have no idea

what became of them, begin by checking city directories for the town in which they last lived around the time you estimate they moved away. If you cannot be sure of the decade, pick a year in which you know the relatives lived in your locale and check city directories five years at a time until the name disappears from the listings, narrowing it down from there. The city directory should list the family's destination, which will give you more to go on.

When you must rely on public sources in your search for photographs, newspapers can be of considerable assistance to you in locating photos of your ancestors or relatives from more recent decades. Published obituaries as well as wedding and engagement announcements offer opportunities to find copyable pictures of relatives. Obituaries often carry photos of prominent citizens; in some papers, pictures are customarily included with death notices. Marriage announcements provide an ideal opportunity to get a glimpse of a relative that you might never have met or with whom you have fallen out of touch.

Give careful consideration to the possibility that other relatives may have had their picture in the local paper at one time for a special event or occasion—a four-generation photo to accompany a birth announcement, for instance, or a fiftieth wedding anniversary party. Vital statistics records will give you the specific date of the marriage; it is simple to project an approximate time a photo might have appeared in the local newspaper fifty years later. Relatives within the past few decades who belonged to any local clubs, societies, or organizations, who held office, or who were actively involved in civic groups might very well have had their photograph in the local paper at some point in time. You will be forced to rely on your own memory or that of others for the precise date of publication, unfortunately, because most newspapers do not have an index for photographs, although you might

contact the appropriate organization for a specific date in their records. Do not consider the situation hopeless, however, until you have checked with others for anyone who might remember when it appeared in the paper or who might have saved the original clipping. If they happened to jot down the date on the clipping, you can then look up the photo on microfilm and make a copy of it for yourself or make a photocopy directly from theirs.

Do not overlook businesses or industries where ancestors of yours worked at one time. Such companies, particularly the larger ones, probably have public relations offices that have produced internal publications that may well have included a photo of your relative, especially if the individual had been with the company for some time.

Do not disregard information that may be learned from yearbooks, which have a value all their own; they include not only photographs of graduates but often background and personal information as well. Consider yearbooks from institutions such as technical schools and nursing schools as well as more traditional schools such as high schools, colleges, and universities. If you already know the high school or college an ancestor graduated from, the school's yearbook represents an easy way of getting copies of photos and is especially helpful if you do not know what the relative looked like or if you have no other photos of the person. The libraries or alumni offices at individual schools and colleges could be of help to you in locating old copies of their publications if you already know the date, which you can reasonably determine by talking with relatives or from city directories for the town in which your ancestors grew up. If you find an old yearbook in the attic of a family home, it was undoubtedly saved for a reason. Note who signed the book and to whom the

salutations are addressed if there is no name in the front of the book.

Also, remember your local historical society library for collections of photographs that are already identified. It may seem a long shot, but their staff has access to records and archives that may contain information from photographers' files. They would also be likely to have photos of prominent citizens within the community. If the ancestor whose photograph you seek was active in politics or civic affairs, it could be well worth your while to check with your local historical society's librarian.

There is always the possibility of enlarging your collection of family photographs by adding to your present grouping with more of your own photos. While it does not increase the number of ancestral photos in your possession, it is certainly a step in the right direction for future generations. There is always the chance that you will accumulate more photographs of your forebears through attendance at a family reunion where copies of old photos are likely to be circulating. Be sure to identify and date all of your own photographs as soon as possible while the names are fresh in your mind so that you will not be guilty of the same mistakes your ancestors made in not labeling theirs, particularly if you are fortunate enough to be able to attend a reunion where you will find so many branches of the family gathered together at once. Never label with ink; use an all-graphic pencil. Label under images rather than on top of them.

Family reunions also present a golden opportunity to locate someone who might be able to identify your old photos. Be sure to take along any photographs or, better yet, copies of pictures that you have, whether you recognize the ancestors or not. Photos of ancestors who are already identified will stimulate conversation about the individuals in the pictures as well as others. However, do not part with your old photos;

take requests and tell relatives you will have copies made for them, as it is too easy to lose the originals in the shuffle. Then follow through on your promise. Establishing family ties through reunions gives you the chance to make new friends, become acquainted with relatives you have never met before, and open lines of communication between yourself and family members from other states who can provide new channels through which old photographs may eventually reach you.

Flea markets and county fairs are an especially good source of old photographs. You will certainly find a majority of unfamiliar faces among the stacks of photos you will come across; yet many of them probably came from the immediate vicinity, so who knows? Those interested in collecting more historical photographs, whether they are ancestral ones or not, will find more than their share once they begin looking.

If you find yourself with extra copies of family photographs and no one else wants them, you may want to cut them up and assemble your own family tree. I did this for a friend who requested one. A pictorial genealogy is an ideal method of display for anyone who has spent years on research. You can even use photocopies of portraits to make up a family tree of this type by sketching in the base of the tree along with a few branches and leaving places for photos of members in each generation.

You may want to "adopt" ancestors of your choice who are not related to you by displaying old and possibly unidentified photos in your home simply because they possess a certain appealing character and a degree of beauty that is unsurpassed by today's photographic methods. In a roundabout fashion, I inherited some beautiful old photographs in excellent condition after a friend, an elderly widow with no close relations to claim the portraits, passed away a few years ago. Among an assortment of framed silver prints, she had left a

pair of large tintypes of her grandparents which obviously were quite old. The portraits had been stored in my grandfather's cellar, falling eventually into my hands many years after I had first admired them on the wall of her apartment in my grandfather's house. They were not my own ancestors, of course, but neither were they strangers, and I regretted that I had not learned their names while she was alive. It left me with more photographs to be identified, more names to be sought out in public records. Many such exquisite examples of early photography are still in existence today and go begging for a home because they are unidentified.

Although it is tempting at times to do so, never throw out or discard unidentified photographs from your collection. Too many photos have been destroyed by members of the subject's own family because no one saw a reason to keep them. Identification is the key to transforming them from riddles to treasures and to stoking a half-hearted interest in your genealogy to a passion. Rather than allowing them to remain an idle diversion, approach unidentified photos as a tantalizing mystery to be solved. Let them become a mild obsession to stimulate your imagination and set your curiosity afire. The time has come for historical photographs to be recognized as the treasures that they are. Historic photographs represent your gift to future generations. Today's unknown image is the cherished keepsake of tomorrow, a prize that you had a hand in preserving.

The photographs that secure our ancestors' place in time assure them a permanence in our memory as well. Your own quest to identify those photos will lead you down unexpected paths, as you will quickly find that your research is ongoing rather than being a project with a definite ending. The answers you need will probably never be found all at once, but instead you will discover chunks of material at a time, a truly thrilling experience but one that is only to be followed

by a lull before new knowledge can come to light. In the learning process, you will encounter ancestors who may seem to live and breathe through public records as you perceive clearly how you developed into the individual you are as their descendant. Not only will you develop a sense of family pride, but you will gain insight into the customs, actions, and motivations of your predecessors. You may feel an appreciation close to reverence as knowledge of their lives transcends the distance of years and erases the boundary drawn at the grave, for their spirit lives on in their descendants, including you.

Rather than depriving you of individuality, your past gives you a self of clearly defined dimensions. The span of our lives may not overlap that of our ancestors, but their impact is felt in the legacy of family tales and photographs that we inherit. Our very lives are extensions of theirs; we receive our heritage from them with characteristics that remain ours for a lifetime—physical, racial, medical, religious, psychological, physiological. Your search to identify your ancestors through photographs will help you appreciate those inherited characteristics.

NOTES

Chapter 2: Keeping Accurate Records

1. Arlene Bassett, "What Do You Mean, You're My First Cousin Once Removed?," *Yankee* 43:12 (December 1979): 87, 103.

Chapter 5: Recognizing Types of Photographs

1. Robert A. Weinstein and Larry Booth, *Collection, Use, and Care of Historical Photographs* (Nashville: American Association for State and Local History, 1977), 39

2. "Petite Portraits," *Colonial Homes* (October 1988): 135.

3. Weinstein and Booth, 52.

4. Ibid., 4, 12, 68.

5. Ibid., 6.

6. Ibid., 7.

7. Ibid., 198–204.

8. Ibid., 95.

9. Ibid., 97.

10. Ibid., 71.

11. Beaumont Newhall, *The Daguerreotype in America* (New York: New York Graphic Society, 1968), 124.

12. Weinstein and Booth, 68.

13. Ibid., 46.

14. Ibid., 154.

15. Ibid., 164–65.

16. Time-Life Books, *Caring for Photographs: Display, Storage, Restoration* (New York: Time-Life Books, 1973), 45.

17. "Buttons and Badges," *Colonial Homes* (June 1989): 26.

18. Weinstein and Booth, 162.

19. Ibid., 209.

20. Laurence E. Keefe, Jr. and Dennis Inch, *The Life of a Photograph* (Boston: Focal Press, 1984), 283–85.

Chapter 6: Care and Restoration of Photographs

1. Time-Life Books, *Caring for Photographs: Display, Storage, Restoration* (New York: Time-Life Books, 1973), 12.

2. Robert A. Weinstein and Larry Booth, *Collection, Use, and Care of Historical Photographs* (Nashville: American Association for State and Local History, 1977), 103.

3. Time-Life Books, 61.

4. Laurence E. Keefe, Jr., and Dennis Inch, *The Life of a Photograph* (Boston: Focal Press, 1984), 288–93.

5. Time-Life Books, 14–16.

6. Ibid., 44–47.

7. Ibid., 40–43.

8. Ibid., 34–39.

9. Weinstein and Booth, 117–19.

10. Time-Life Books, 142–53.

ADDITIONAL SOURCES

Sources of Public Records

The Family History Library of the Church of Jesus Christ of Latter-day Saints
35 North West Temple Street
Salt Lake City, Utah 84150

The Newberry Library
60 West Walton Street
Chicago, Illinois 60610

Library of the Daughters of the American Revolution
1776 D Street, N.W.
Washington, D.C. 20006

General Register Office
St Catherines House
10 Kingsway
London WC2B 6JP
England
Has certificates of births, deaths, and marriages in England and Wales since 1837.

Registrar General
New Register House
Edinburgh EH1 3YT
Scotland
Has vital statistics records for Scotland from 1855 to the present.

Registrar General
Oxford House
Chichester Street
Belfast BT1 4HL
Northern Ireland
Has vital statistics records for Northern Ireland since 1922. Records prior to 1922 are kept at the General Register Office, Customs House, Dublin, Ireland.

Census Information

National Archives and Record Service
Reference Services Branch
NNIR
General Services Administration
Washington, D.C. 20408

U.S. Department of Commerce
Bureau of the Census
Pittsburg, Kansas 66762

Genealogical Books and Materials

Genealogical Publishing Company, Inc.
1001 North Calvert Street
Baltimore, Maryland 21202

Goodspeed's Bookshop
18 Beacon Street
Boston, Massachusetts 02108

Charles E. Tuttle Company
P.O. Box 541
Rutland, Vermont 05701

Ancestry, Incorporated
P.O. Box 476
Salt Lake City, Utah 84110

Dealers of Archival Supplies

Light Impressions Corporation
P.O. Box 3012
439 Monroe Avenue
Rochester, New York 14614

Eastman Kodak Company
343 State Street
Rochester, New York 14650

Hearthstone Bookshop
Potomac Square
8405-H Richmond Highway
Alexandria, Virginia 22309

Genealogical, Hereditary, and Patriotic Societies

Colonial Dames of America
421 East 61st Street
New York, New York 10021

General Society of Colonial Wars
840 Woodbine Avenue
Glendale, Ohio 45246

New England Historic Genealogical Society
101 Newbury Street
Boston, Massachusetts 02116

Ladies of the Grand Army of the Republic
c/o Elizabeth B. Koch
204 East Sellers Avenue
Ridley Park, Pennsylvania 19078

Pilgrim Society
Pilgrim Hall Museum
Plymouth, Massachusetts 02360

National Society of Colonial Dames of America
Dumbarton House
2715 Q Street N.W.
Washington, D.C. 20007

The Society of Genealogists
37 Harrington Gardens
London SW7 4JU
England

The Scots Ancestry Research Society
20 York Place
Edinburgh 1
Scotland

The Ulster-Scot Historical Foundation
66 Balmoral Avenue
Belfast BT9 6NY
Northern Ireland

BIBLIOGRAPHY

Altick, Richard. *Victorian People and Ideas*. New York: Norton, 1973. A good introduction to the history and culture of the Victorian period.

American Genealogical Research Institute Staff. *How to Trace Your Family Tree*. New York: Dolphin, 1975. Contains especially useful hints for beginners.

Andrist, R. *American Century*. New York: American Heritage Press, 1972.

Barth, Miles. "Notes on Conservation and Restoration of Photographs." *PCN: The Print Collectors Newsletter* 7:2 (May/June 1976): 48–51.

Barton, Lucy. *Historic Costume for the Stage*. Boston: Walter H. Baker Company, 1961. Meticulous detail regarding fabrics, jewelry, accessories, and clothing styles worn by men, women, and children through the years.

Basch, Francoise. *Relative Creatures: Victorian Women in Society and the Novel*. New York: Schocken, 1974.

Bassett, Arlene. "What Do You Mean, You're My First Cousin Once Removed?" *Yankee* 43:12 (December 1979): 87, 103.

———. *Battlefield Weapons and Uniforms of World War II*. Secaucus, N.J.: Chartwell Books, Inc., 1978. Photographs.

Betjeman, John, ed. *Victorian and Edwardian London from Old Photographs.* New York: n.p., 1969.

Black, Carla. "Preserving Paper Heirlooms." *Country Living* 13:2 (March 1990): 54, 56.

Bowers, Q. David. *Encyclopedia of Automatic Musical Instruments.* New York: Vestal Press, 1972.

Bradfield, Nancy. *900 Years of English Costume.* London: Crescent Books, 1970.

Braive, M.F. *The Photograph: A Social History.* New York: McGraw-Hill, 1966.

Branca, Patricia. *Silent Sisterhood.* N.p.: Carnegie-Mellon, 1975.

Brian, C. "The Early Paper Processes, the Recognition of Early Photographic Processes, and Their Care and Conservation." Royal Photographic Symposium, 16 March 1974, London.

Briggs, Asa. *Victorian Cities.* New York: Harper & Row, 1970.

Brown, M. H., and W. R. Felton. *The Frontier Years.* New York: Bramhall House, 1954.

———. *Color Treasury of Military Uniforms.* London: Crescent Books, 1973. Illustrations.

"Buttons and Badges." *Colonial Homes* 15:3 (June 1989): 22–28.

Crawford, William. *The Keepers of Light: A History & Working Guide to Early Photographic Processes.* Dobbs Ferry, N.Y.: Morgan & Morgan, 1979.

Davies, Thomas L. *Shoots: A Guide to Your Family's Photographic Heritage.* Danbury, N.H.: Addison House, 1977.

Dolloff, Francis W., and Roy L. Perkinson. *How to Care for Works of Art on Paper.* Boston: Museum of Fine Arts, 1971.

Doten, Hazel R., and Constance Boulard. *Costume Drawing.* New York: Pitman, 1956.

Feldman, Larry. "Discoloration of Black and White Photographic Prints." *Journal of Applied Photographic Engineering* (February 1981): 1-9.

Gernsheim, Alison. *Victorian and Edwardian Fashion: A Photographic Survey.* New York: Dover, 1981.

Gernsheim, H. *The History of Photography.* London: Oxford University Press, 1955.

Gernsheim, Helmut, and Alison Gernsheim. *The History of Photography from the Camera Obscura to the Beginning of the Modern Era.* New York: McGraw-Hill, 1969.

Gill, Arthur. "Recognition of Photographic Processes." *History of Photography* 2:1 (January 1978): 34-36.

Gorham, M. *Ireland Yesterday.* New York: Avenel, 1971.

Gouldrup, Lawrence P. *Writing the Family Narrative.* Salt Lake City: Ancestry, 1987.

Hellerstein, Hume, and Offen Hellerstein, eds. *Victorian Women: A Documentary Account of Women's Lives.* Stanford, Calif.: Stanford University Press, 1981.

Houghton, Walter. *The Victorian Frame of Mind.* New Haven: Yale University Press, 1958. Offers insight into the social and moral concerns of Victorian thought.

Humeston, Barbara. "Gathering the Generations." *Better Homes and Gardens* 64:9 (February 1986): 91-95, 144, 147.

Jackson, C. *Picture Maker of the Old West.* New York: Charles Scribner's Sons, 1947.

Jensen, O., and J. P. Kerr. *American Album.* New York: American Heritage Publishing Co., 1968.

Johnston, Susan. *Fashion Paper Dolls from Godey's Lady's Book, 1840-1854.* New York: Dover, 1977.

Jordan, R. F. *Victorian Architecture.* Gretna, La.: Pelican Books, 1966.

Jordan, Charles J. "Machines That Make Music." *Yankee* 45:5 (May 1981): 122-29. Briefly discusses Victorian musical photograph albums.

Katcher, Phillip. "How to Date an Image From Its Mat." *PSA Journal* 44:8 (August 1978): 26.

Keefe, Laurence E., Jr., and Dennis Inch. *The Life of a Photograph.* Boston: Focal Press, 1984. Includes a helpful guide on methods of taking apart old frames and reframing aged prints.

Kraus, Michael, and Vera Kraus. *Family Album for Americans.* New York: Grosset & Dunlap, 1961.

Kybalova, Ludmila, Olga Herbenova, and Milena Lamarova. *The Pictorial Encyclopedia of Fashion.* New York: Crown, 1970.

Lord, Francis A., and Arthur Wise. *Uniforms of the Civil War.* New York: A. S. Barnes and Company, 1970.

Martin, P. *Victorian Snapshots.* London: Country Life, 1939.

Menten, Theodore. *Victorian Fashion Paper Dolls from Harper's Bazar, 1867-1898.* New York: Dover, 1977.

Minto, C. S. *Scotland in Old Photographs.* London: Batsford, 1970.

Morgan, Willard D., ed. *The Encyclopedia of Photography.* N.p.: Greystone Press, 1967.

Morrison, Alex. *Photofinish.* New York: Van Nostrand Reinhold Company, 1981.

Murphy, Bill. "Family Reunion Vacations." *Better Homes and Gardens* 67:8 (August 1989): 123–24, 126.

The Museum of Modern Art. *The History of Photography from 1839 to the Present Day.* New York: Doubleday, 1964.

Naylor, Lois Anne. "Family Reunion Vacation." *Better Homes and Gardens* 68:7 (July 1990): 133–36, 138, 141.

Newhall, Beaumont. *The Daguerreotype in America.* New York: New York Graphic Society, 1968. Comprehensive and detailed discussion of the history of the daguerreotype.

Ostroff, Eugene. "Preservation of Photographs." *The Photographic Journal* 107 (October 1967): 309–14.

"Petite Portraits." *Colonial Homes* 14:5 (October 1988): 134–37, 200.

Polk, Milbry C., and William A. Price. "An Old Family Comes Home." *Americana* 13:6 (January/February 1986): 54–56.

Pollack, P. *The Picture History of Photography.* New York: Harry Abrams, 1970.

Preservation of Photographs. Kodak Publication F-30. Rochester, N.Y.: Eastman Kodak Company, 1979.

Quinlivan, Connie, and Jack Foley. "How to Plan a Family Reunion." *Family Circle* 102:10 (July 25, 1989): 82.

Reilly, James M. *The Albumen and Salted Paper Book: The History and Practice of Photographic Printing, 1840–1895.* Rochester, N.Y.: Light Impressions, 1980.

Rodgers, Mary Augusta. "Finding Yourself on Your Family Tree." *Woman's Day* (May 3, 1977): 73, 136, 138.

Schuyler, Hartley, and Graham Schuyler. *Illustrated Catalog of Civil War Military Goods.* New York: Dover, 1985.

Shull, Wilma Sadler. *Photographing Your Heritage.* Salt Lake City: Ancestry Inc., 1988.

Snelling, H. H. *The History and Practice of the Art of Photography.* Introduction by Beaumont Newhall. Hastings-on-Hudson, N.Y.: Morgan and Morgan, 1970.

Szarkowski, J. *The Photographer and the American Landscape.* New York: Museum of Modern Art, 1963.

Taft, R. R. *Artists and Illustrators of the Old West.* New York: Charles Scribner's Sons, 1953.

Taft, Robert. *Photography and the American Scene: A Social History, 1839–1889.* N.p.: Dover, 1964.

Tierney, Tom. *American Family of the Civil War Era.* New York: Dover, 1985.

Time-Life Books. *Caring for Photographs: Display, Storage, Restoration.* Time-Life Library of Photography. New York: Time-Life Books, 1973. Contains a particularly informative section on professional techniques used in restoring old photographs.

Trivette, Don. "Family Tree Maker Brings Easy Genealogy to Everyone." *PC Magazine* (May 15, 1990): 389.

Van Atta, Dale. "The Joys of Ancestor-Hunting." *Reader's Digest* 129:771 (July 1986): 144–48. A humorous and inspiring account of the process of tracing one's ancestry.

Vanderbilt, P. "Picture Collections and the Local Historical Society." *History News* 11:5 (May 1958).

van Hasbroeck, Paul Henry. *150 Classic Cameras from 1839 to the Present.* New York: Sotheby's Publications, 1990.

Victorian People. New York: Harper and Row, 1955.

Vestal, David. "Are Your Prints Fading Away?" *Popular Photography* 64:4 (April 1969): 67–69, 106–09.

Vicinus, Martha. *A Widening Circle.* Indiana: n.p., 1977.

——. *Suffer and Be Still: Women in the Victorian Age.* Indiana: n.p., 1973. Two particularly good discussions by the author of the position of women in the Victorian world.

Weinstein, Robert A., and Larry Booth. *Collection, Use, and Care of Historical Photographs.* Nashville, Tenn.: American Association for State and Local History, 1977. A thorough and informative account of the history of different photographic styles and of the proper methods for treating and preserving a collection.

Wolff, Michael, and H. J. Dyos. *The Victorian City: Images and Realities.* London: n.p., 1973.

Wolfman, Ira. "Great Family Reunions." *Family Circle* 102:10 (July 25, 1989): 78–80, 145–46.

Index